IMAGES
of Aviation

SPRINGFIELD AVIATION

Best wishes!

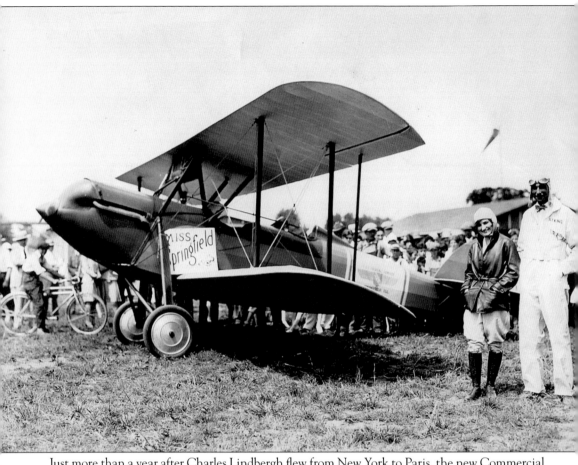

Just more than a year after Charles Lindbergh flew from New York to Paris, the new Commercial Airport, four miles southwest of Illinois' Capital City, celebrated the opening of Aerial Week with a July 29 photo op featuring pilot Craig Isbell and passenger Beraldine (Berl) Crumly, who was Miss Springfield in 1928. Isbell was co-owner of L&I Aerial Service Company, Springfield's first fixed base operator (FBO), which began just months before at Bosa Field, northwest of the city. Years later, Crumly would marry Dean Daykin, and the couple would live two doors north of the author's childhood home. Dean and Berl would remain family friends for life. Only when researching this book did the author learn of her connection to early aviation.

On the cover: Please see above. (Photograph courtesy of the Sangamon Valley Collection.)

IMAGES
of Aviation

SPRINGFIELD AVIATION

Job Conger

ARCADIA
PUBLISHING

Published by Arcadia Publishing
Charleston SC, Chicago IL, Portsmouth NH, San Francisco CA

Printed in the United States of America

Library of Congress Catalog Card Number: 2008929314

For all general information contact Arcadia Publishing at:
Telephone 843-853-2070
Fax 843-853-0044
E-mail sales@arcadiapublishing.com
For customer service and orders:
Toll-Free 1-888-313-2665

Visit us on the Internet at www.arcadiapublishing.com

This book is dedicated to Slip 'N' Skid Fliers Club
of Springfield, Illinois.

CONTENTS

ACKNOWLEDGMENTS

Richard Strouse, husband of Connie Walker Strouse, and Bill Strouse, his brother, corresponded almost daily with the author and generously provided the story and photographs of John Thornton Walker, shared too briefly in Chapter 5. Walker's story merits greater sharing, and I intend to do that locally, following publication of this book. Many pictures of Springfield Commercial/Municipal Airport also came from the family collection.

Of inestimable help were Springfield city historian Curtiss Mann, his associates, and the Craig Isbell Collection, now a part of the Sangamon Valley Collection (SVC) of Lincoln Library. Many pictures in that collection were taken by C. W. Chiles, a major photographer of the 1930s. Fully 80 percent of the pictures taken before 1948 and included in this book came from the SVC.

Special thanks to William Larkins. His considerable digging into quaint and curious volumes of forgotten lore allowed me to connect many aircraft to names in these pages.

Everyone mentioned here and a small community of Springfield enthusiasts who share my passion for flying provided facts and inspiration to carry this project to fruition. Thanks to all, and God bless them, every one!

Photograph credits are listed as follows: 183rd Fighter Wing, Illinois Air National Guard (183rd FW), Official U.S. Navy (USN), AeroKnow Collection (AK), Joe Angermeier (JA), Dave Beatty (DB), Beech Aircraft Corporation via AK (BA), Ken Boeker (KB), Chanute Air Force Base Archives (CAFB), Job C. Conger III (JCIII), the author (JC), Les Eastep (LE), Gary Fleck (GF), C. S. Hartley collection (JH), Loren Jenne (LJ), William Larkins (WL), Abraham Lincoln Presidential Library (ALPL), Corwin H. Meyer (CHM), Springfield Airport Authority (SAA), Springfield Air Rendezvous (SAR), Sangamon Valley Collection (SVC), and Connie Walker Strouse (CWS).

Special thanks to Slip 'N' Skid Fliers Club of Springfield. The group of general aviation pilots hosted my first aviation history slide presentation at Harness House Restaurant in the mid-1970s, and our paths have convivially crossed ever since. They have welcomed my camera and me aboard group flights for $100 hamburgers; to their gatherings at hangar F-7, where Jim Walker kept his TriPacer, later Cherokee; and to their cookouts at Jim Thornton's hangar on Charlie Ramp in later years. When I dropped by their array of lightplanes displayed during Springfield Air Rendezvous, they shared their coffee and donuts as though I had chipped in for them. The group continues today, welcoming new members and anyone who just wants hang and talk flying.

INTRODUCTION

If a merchant-turned-lawyer named Abraham Lincoln had not moved from the village of New Salem, Illinois, to nearby Springfield, this book would never have been written. The future "Great Emancipator's" efforts to relocate the state capital from Vandalia to his new home in 1839 gave the city more prominence and more stability as an enterprise (all cities are "enterprise zones") than it would likely have earned without him. Even so, it has been the fashion, almost since his death in 1865, for local citizens to downplay his effect on the present collective well-being of its people. Some "truths" connected with the subsequent growth of aviation in the city remain immutable.

One is that Lincoln, from his White House lodging in Washington, D.C., authorized the nation's first air force, setting into play wide-spread appreciation of "air" as the ideal perch for all who want to see over the next hill and many who want to see beyond tomorrow. Another is that given the concentration of so many politicians crammed into the space beneath the state capitol dome and related buildings, there would always be a stable base of support for transportation in and out of town. Industries will come and go, but politics lives forever. The need for modern transportation was manifested most meaningfully, in recent years, in the establishment of the Illinois Department of Transportation's Division of Aeronautics facility created at Capital Airport in 1979.

"Honest Abe" aside, Springfield's populace as a whole has embraced aviation the way a citizen might embrace a brown bear encountered in the kitchen at 3:00 a.m., and the ensuing outcome is not entirely the fault of the bear. Located just 100 miles northeast from St. Louis and 200 miles southwest of Chicago, Springfield is almost too close to larger metropolitan concentrations that require prime aviation resources to serve them. Today ground transportation taxis advertise front door-to-airport delivery to Lambert, St. Louis. Bloomington-Normal's Central Illinois Regional Airport, 60 miles up Interstate 55, has undergone a modern Renaissance of growth as an alternative to Peoria's Greater Peoria Regional. Amtrak passenger rail service ridership numbers have shown recent increases.

Despite its population of 111,454 (2000 census), Springfield is as much a neighborhood to longtime residents as it is a city. It is known for its 15-minute rush hour, as throngs of politicians and their kin fight 7:30 a.m. traffic heading in from the western suburbs to the heart of downtown where most government jobs, which have not been relocated to Chicago by the current governor, remain. A 10-minute scenic charter flight will allow any aero-historian-tourist to gaze down on land that once was home to its three former airports. Add another 10 minutes to the itinerary, and you can take in most private airstrips as well.

A May 1, 1939, front-page editorial cartoon in the city's *Illinois State Journal* shows our nation's national bird, named "Springfield Aviation," languishing on the gently rolling prairie as dozens of aircraft pass by overhead. The title of artist Carl Somdal's fine rendering is "Lone Eagle." In the pages of this book, readers will learn the forces behind his illustration.

In some ways, the surviving Abraham Lincoln Capital Airport's (SPI) liabilities are at the same time among its finest assets. Runway 22/4 (short for compass headings 220 degrees and reciprocal 40 degrees) is 7,999 feet long and 150 feet wide; one of the longest in the Midwest. The first flight of McDonnell Douglas's prototype F/A-18 Hornet touched down at SPI before returning home. Why truck a new design to Edwards Air Force Base in distant California when they could fly to SPI? Subsequent testing continued at Edwards and elsewhere, of course. New hires for national airlines frequently shoot touch-and-go landings at SPI. So do the fine folks at Scott Air Force Base in southern Illinois. With state-of-the-art navigation aids and communications facilities, it is an ideal base from which to learn how to fly. A modern hotel, historic Lincoln Tomb, and an aviation museum are located less than five minutes from the main gate to the airport off J. David Jones Parkway.

On a personal note, this author was delighted when asked by Arcadia Publishing to write this book. As founder of a large aviation data bank and model airplane "museum" called AeroKnow and a participant in 22 of the 24 Springfield Air Rendezvous air shows, including the first three, I have met many of the principals connected with Springfield's remaining airport. In the course of writing this book, I have met a few more and found them all generous of time and resources.

As a child, I bicycled to Southwest Airport and later Capital Airport with camera in hand, just to take pictures and watch the airplanes. I took my first airplane picture at Southwest Airport in 1962 and am pleased to include it here. Today I would no more visit any airport without my camera than I would visit without my pants. I consider both essential for the maximum enjoyment of aviation.

The greatest challenge in putting this book together has not been finding enough pictures; it has been deciding what pictures to leave out. Some dilemmas created by the lack of public documentation of Fleck's Air Park and other small area airports were solved almost at the last minute by fine people who had not realized I was up against a deadline. Gary Fleck, a son of Frank "Bud" Fleck, and Dave Beatty helped a lot. So did careful attention to the phone books at Lincoln Library's Sangamon Valley Collection. What had been understood as a thriving general aviation airfield was something less, vanished from the phone books by 1948. My quest for more of the story of the Fleck enterprises continues though the book must present what was known at deadline.

The greatest lesson learned by this author is twofold. The Internet, which I anticipated would provide answers to questions, all too frequently came up short. Why? My guess is that many fine individuals who have photographs and facts worth sharing have no interest in engaging the 21st century medium of computer technology to do it. The single happiest exception to that circumstance was my fortuitous encounter with Bill Strouse, described elsewhere. I met kind people with fading memories and photographs stored in boxes in high closet shelves they can no longer reach. They do not understand the importance of the resources they have and the growing need to share those resources with public collections. My earnest hope is that anyone with aviation photographs and stories to tell will dig them out and deliver them to an interested, eager aviation community, ready to give them all the glory for their courtesies. For most of my life, I have considered myself an aviation historian before all other callings, a storyteller, a recorder of stories. I hope other aviation enthusiasts will consider their own lives and the lives of their aviation-connected families in the same way.

Readers will notice registration numbers appearing in parenthesis following the airplanes' names and designations in photograph captions in this book. An example is Curtiss P-40E (N40PE ex AK705). The "N" number is the civilian registration number carried on the fuselage and wing and the "ex" number is the original military service serial number. The information is provided for the benefit of current and future aviation historians who track the histories of individual airplanes.

There are myriad tales of aviation in our own villages and cities that should be told to the world. What a shame it would be for our apathy or failure to appreciate them should allow those stories to die unspoken.

One

THE LINEN AGE, 1858–1925

Silas M. Brooks, who performed the first human flight in Illinois on July 4, 1855, came to Springfield's new Capital City three years and a day later and learned how frustrating it can be attracting ticket buyers to an air show when one cannot deliver a jet team. Too many citizens enjoyed the view as soon as the aeronaut ascended above the canvas barrier erected to part them from their 50¢ of silver. It would not be the last Springfield air show to fail to show a profit.

Springfield's most famous citizen, Abraham Lincoln, authorized creation of the nation's first air force. Thaddeus S. C. Lowe convinced the 16th president to authorize the "Aeromatic Corps of the Army," a hydrogen balloon corps, to spy on Confederate troops.

Howard L. Scamehorn's superb book *Balloons to Jets* credits C. T. Pritchett for the first airplane built in Springfield. The year was 1909. No one remembers its designer or if it even flew.

In 1910, the Wright exhibition organization scouted the Illinois State Fairgrounds racetrack infield and requested the removal of several trees prior to arranging several days of exhibition flying. The state agriculture department assented and thus was born Springfield's first airport. Exhibitionists Walter Brookins, Arch Hoxsey, and Lincoln Beachey would fly for audiences of thousands there. Julia Clark, who was a recent graduate of the Curtiss Flying School, died practicing for a 1912 show there. Until the early 1920s, it would be the city's only public venue where aircraft flew regularly.

A 1922 effort cosponsored by the chamber of commerce and flown by a U.S. Army pilot resulted in one airmail flight carrying Springfield postmaster Albert J. Pickel from a hastily prepared field off north Walnut Street Road. Four years later, an ordinary April downpour "precipitated" what would become a full-circle series of events from that field. About that time, farmer William Bosa allowed local pilots to fly from his field northwest of the city. A local citizen watched planes come and go from that field years before anyone heard of a young airmail pilot named Charles Lindbergh.

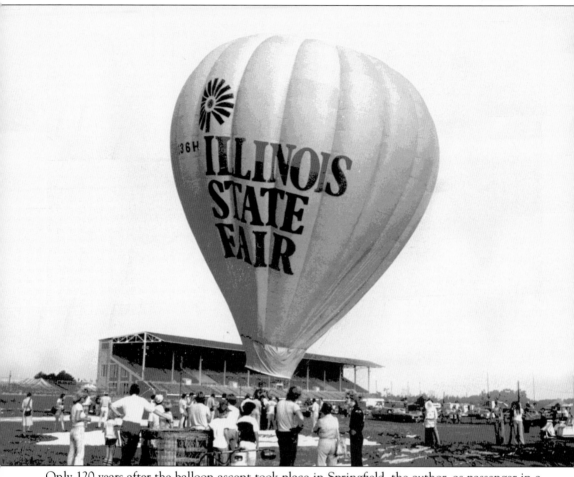

Only 120 years after the balloon ascent took place in Springfield, the author, as passenger in a Peoria-based balloon, was part of the Second Annual State Fair Balloon Race on August 15, 1978. It was a "hare and hound" event where the "hare" rises first, followed minutes later by the "hounds," whose pilots pursued it on winds that varied in direction at different altitudes. Once the hare landed, the hounds maneuvered as close as possible to the downed balloon to drop a small bag of Illinois corn with the pilot's name as close to the hare as possible, before landing a safe distance away and ultimately returning to the fairgrounds. The distant grandstand, built in 1928, replaced the one built in 1895, seen by early visiting aeronauts. Nonetheless it provides similar perspective. Participants began preparation before dawn and were airborne by 7:30 a.m. By noon, all had safely returned to the fairgrounds in time to enjoy a tasty luncheon and awards ceremony on the roof of the Illinois Building. (JC)

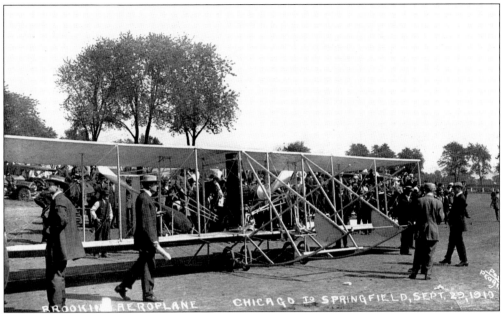

At 4:27 pm, September 29, 1910, Walter R. Brookins landed his Wright biplane at the fairgrounds racetrack infield, only recently shorn of trees to make way for the big event. Though intended to be a non-stop flight from Chicago, headwinds forced him to land at Gilman and Mount Pulaski to refuel. The two villages thus recorded probably their first visits by an "aeroplane," and likely the last for years to come. (BT.)

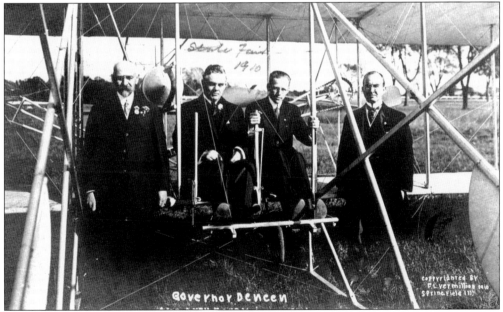

Arch Hoxsey, with hands on the controls, was joined by Gov. Charles S. Deneen at the Illinois State Fair in October 1910. Hoxsey, a native of Staunton, Illinois, was one of the original demonstration team assembled by Orville and Wilbur Wright who were facing stiff airplane sales competition from Glenn Curtiss of New York. During the fair, Hoxsey was slated to fly daily, weather permitting, except Sundays. (BT.)

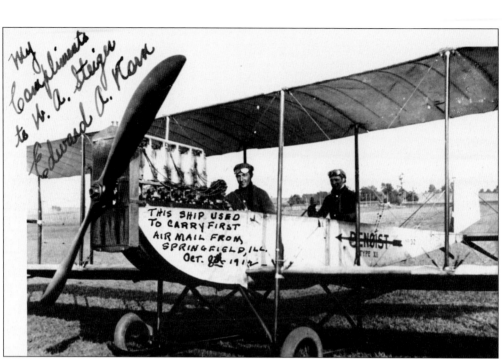

Edward A. Korn flew the first airmail from Springfield on October 8, 1912, in a Benoist biplane, but he did not deliver it anywhere but to the state fair race track infield from where he had ascended. Once aloft, he found the weather too threatening and returned. Horace F. "Sure Shot" Kearney completed the first airmail flight to Williamsville, 13 miles northeast, on October 9 in a Curtiss machine and returned to the fair the next day. (ALPL.)

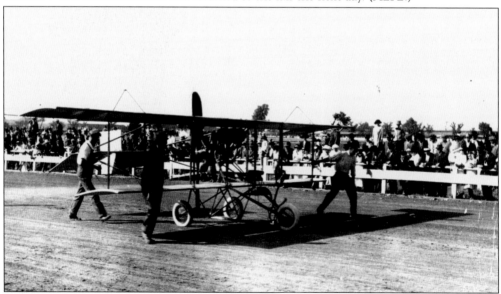

Unlike the ultra-conservative Wright exhibition flyers, Lincoln Beachey performed "close to the edge" for the Curtiss team; not just demonstrating, but dazzling awe-struck thousands at the 1913 Illinois State Fair. From the start, Curtiss machines used ailerons instead of wing warping to bank the aircraft in flight. Note also what for years would be called "Curtiss-type landing gear" and today is called simply tricycle gear, which permitted easier ground handling. (ALPL.)

Photographed near Chanute Field in Rantoul, Illinois, in late 1918, is this Curtiss JN-4D, known as the Jenny. Jennies manufactured and flown in Canada were called Canucks. That type was flown when future Springfield attorney Howard Clayton Knotts was sent to Canada for flight training after he enlisted in the U.S. Army Air Service. Shipped overseas in August 1918, Knotts was assigned to the 17th Aero Squadron, flying Sopwith Camels. (CAFB.)

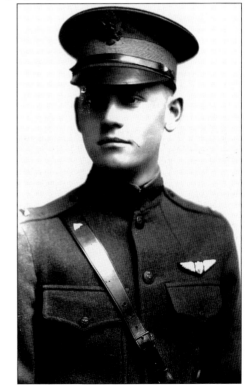

When most U.S. fighter pilots flew the relatively fragile Nieuport 28 and speedy (but not agile) SPAD biplanes, the Sopwith Camels flown by the 17th Aero Squadron were probably the most dangerous (to their own pilots) in the sky. Knotts downed six German aircraft on routine operations before he was brought down by the enemy. En route to prisoner of war facilities, he set afire and destroyed seven German fighter planes (Fokker D.VIIs) on a flat car, part of the same train. (ALPL.)

The British-designed de Havilland DH-4B single-engine bomber, pictured here in the United States about 1920, was the only U.S.-built landplane to see combat in World War I. Evident is the round rear defensive position where a gunner wielded a single small-caliber machine gun on a swivel mount against intercepting German fighters. The DH-4M modified, with no rear gun position and an added compartment for mail sacks forward of the cockpit, became the standard airmail transport in the mid-1920s. (CAFB.)

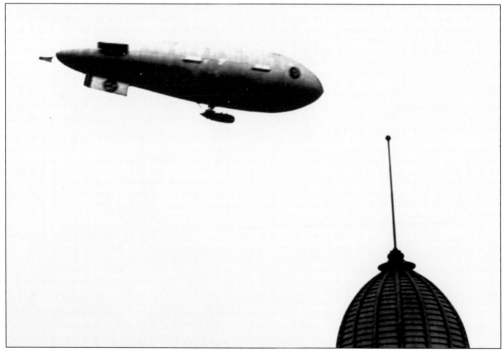

This U.S. Army Goodyear A-4 airship was photographed circling the Sangamon County Building in 1923. Unlike giant rigid-frame dirigibles of World War I, it was a simple, collapsible bag of hydrogen gas that maintained its shape with internal pressure against the inside of the envelope. A training ship, powered by an OX-5 engine and crewed by three in the underslung gondola, the A-4 buzzed along at a blistering 46-mile-per-hour top speed. (SVC.)

Two

THE BRASS AGE, 1926–1930

Fleck's Motel, located at Chatham Road at Jefferson Street, was a fulcrum of early aviation history. A turn west onto Jefferson Street would lead to Bill Bosa's field, though Bert Fleck remembers pronouncing it "Boze." As a child, she enjoyed picnics there while watching the airplanes come and go. A turn south on Chatham Road would lead to the new airport after it came along.

In the spring of 1926, Robertson Aircraft sent Charles Lindbergh and Phillip Love up to select a field for airmail operations. Spring rains had flooded the site north of the city that had been suggested earlier as ideal. Instead Bosa Field was recommended, and a long-term lease was signed for its use in cooperation with the chamber of commerce. A much-ballyhooed practice run was made on April 10. *Illinois State Register* editor V. Y. Dahlman, who had flown as passenger on the practice run, described "Conkling Field." The two names referred to the same airport. The first official airmail flight was flown on April 15.

Craig Isbell had managed Robertson Aircraft's Peoria station in 1926 but was reassigned to Bosa Field soon after. He partnered with Springfieldian Gelder Lockwood to form L&I Aerial Services.

By the summer of 1927, the limited growth potential at Conkling Field was obvious. L&I Aerial Services moved south down Chatham Road to the new Springfield Commercial Airport, southwest of downtown and set up shop. L&I Aerial Services and Leslie van Meter coleased the land from the Coleman estate.

Among thousands who welcomed the "Lone Eagle" back to his old airmail field August 15, 1927, was Corwin Meyer, who would score his own glory for the city in the years ahead. On his return from honors in the city, the Paris flyer witnessed the rededication of the first airport to be officially named Lindbergh Field. Lindbergh Field ceased operations May 1, 1929.

The first Women's Air Derby, part of the 1930 National Air Races in Chicago, passed through Springfield Commercial Airport. Among the many nationally known aviatrixes was Amelia Earhart. It would not be her last visit to the city.

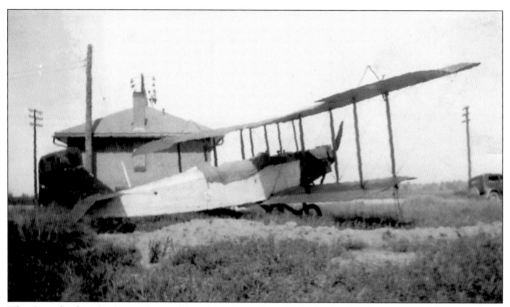

The Standard J-1 biplane pictured here, likely at Bosa Field in the 1920s, was a stablemate of the Curtiss Jenny. Carl Burdinsky, who lived on Springfield's North Grand Avenue, flew his from a field across the street. That field is now part of Camp Lincoln, headquarters of the Illinois National Guard. Stanley Kluzek, who also owned a Standard in 1929, would gain fame 10 years later for a planned flight to his homeland. (SVC.)

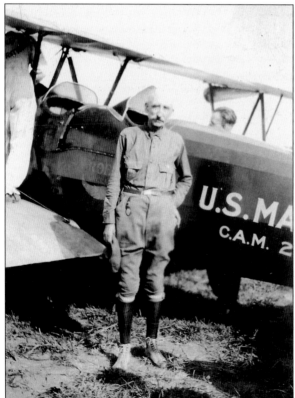

Springfield's Charles Lamond was 10 years old when the Civil War began in 1861. When photographed next to this mail plane at Bosa Field in 1927 at the age 76, he was an experienced parachute jumper. Note that the Robertson CAM2 mail plane next to him is more modern than the DeHavilland DH-4 that Charles Lindbergh flew from Bosa Field before his famous trip to Paris. (SVC.)

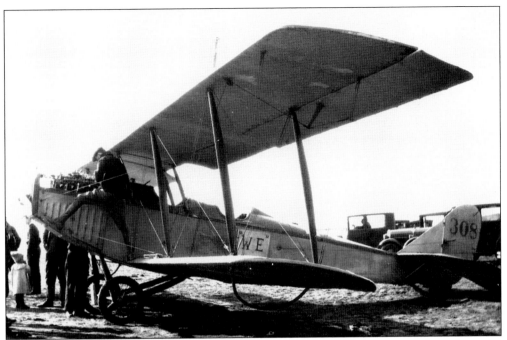

A civil Jenny, pictured here at Bosa, is typical of those flown by barnstormers throughout the 1920s. Sometimes flashing slogans or pet names, Jennies were part of the "salad" days of many young pilots on their way to loftier pursuits. Many migrated south during winters; others joined air circuses that brought performers together in tidy air show packages, a business technique used to this day by impresarios of modern flying talent. (SVC.)

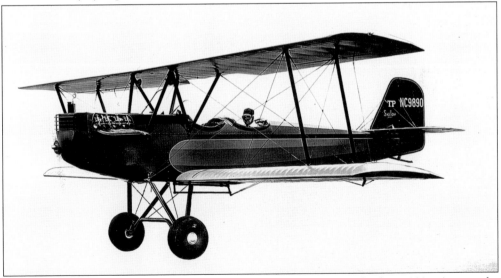

Everyday wear and tear took most Jennies off the active roster by the late 1920s. Among the replacements offered was this Swallow TP, shown here in a factory photograph. Powered by the Curtiss OX-5 engine that had powered the planes they replaced, the Swallow TP (training plane) was a sturdy bird, ideal for use in flying schools that were proliferating throughout the countryside in 1929 like dandelions in June. A Swallow (version unknown) was owned by R. W. Barb and W. Stubbs, whose address indicates a business in the heart of downtown Springfield. (ALPL.)

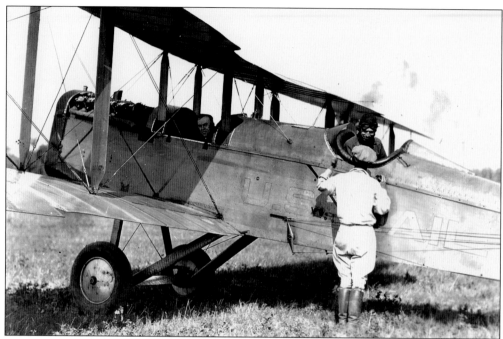

Dated September 23, 1922, this photograph shows an early U.S. airmail plane departing Springfield with "Mr. Thompson, pilot" and "Mr. Albert L Pickel, Superintendent of Mail" in front. Location is thought to be an airfield on north Walnut Street near or on the site of the current Abraham Lincoln Capital Airport (also known as just Capital Airport). It may be the same field viewed from the air by Charles Lindberg four years later and rejected in favor of Bosa Field. (SVC.)

The first "official" airmail flight was flown by Charles Lindbergh from Bosa Field on April 15, 1926, following dedication ceremonies led by Springfield postmaster William J. Conkling. Soon after, an Iowa kid who had only recently become a pilot and the manager of the Peoria Robertson facility was reassigned to manage its Bosa Field station. Later Craig Isbell partnered with Springfieldian Gelder Lockwood. They launched L&I Aerial Service at Bosa field. (SVC.)

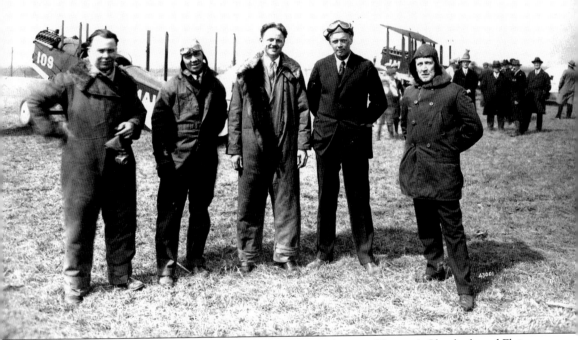

On April 10, 1926, Robertson pilots flying a practice mail run to Chicago's Checkerboard Flying Field on Roosevelt Road just south of the city stopped in Springfield to welcome a few distinguished passengers aboard. Pictured left to right are D. J. Brandewide, superintendent of Robertson Aircraft; pilot Phil R. Love; Ray Alexander of the *St. Louis Post Dispatch*; Charles Lindbergh; and *Illinois State Register* managing editor V. Y. Dahlman. Following his return to Springfield the next day on the return flight south, Dahlman wrote eloquently of his experience in the April 12 *Illinois State Register*. He noted that the first airmail letter sent to Chicago was sent by Springfield Chamber of Commerce member Raymond V. Bahr, who was also the recipient of the first air mail to reach Springfield from the Windy City. (SVC.)

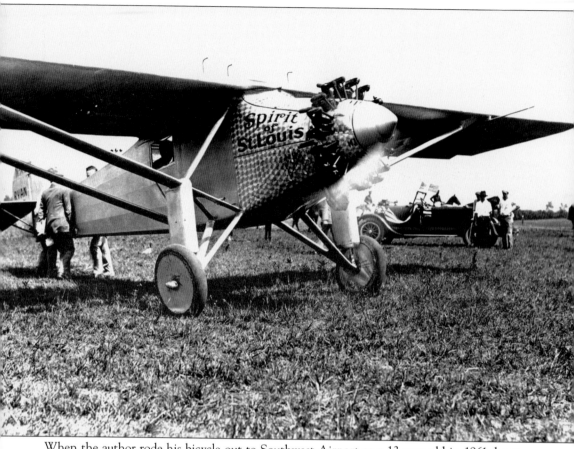

When the author rode his bicycle out to Southwest Airport as a 13 year old in 1961, he saw a picture of Charles Lindbergh's *Spirit of St. Louis* in the terminal's main hall. Thirty years hence, he encountered a picture of the *Spirit of St. Louis* in the terminal of Capital Airport. Later he was allowed to scan a borrowed print of the airplane for this book. Every picture was a reprint of the same original, likely taken by Craig Isbell or Gelder Lockwood on August 15, 1927, during the Lone Eagle's post-Paris national tour of the United States. That day, Lindbergh was given a parade through beautiful downtown, placed a floral wreath during a visit to Lincoln Tomb at Oak Ridge Cemetery, and on his return to Bosa Field, it was officially renamed Lindbergh Field in his honor. It was the first airport to be officially named for him. He was told that the new airport slated to replace the current airport would be named Lindbergh Field as well. That was not to be. (JA.)

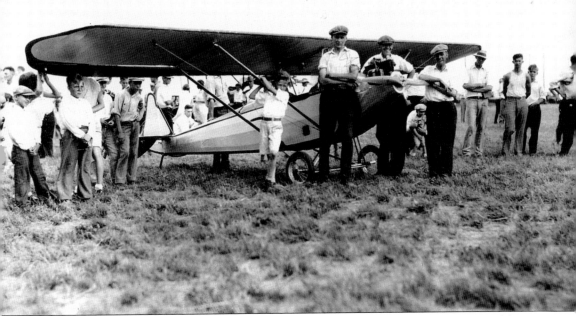

One of the first popular "homebuilt" airplanes, this single-seat Heath Parasol, powered by a Henderson motorcycle engine, was photographed July 3, 1929, at Commercial Airport. Posing with it are Frank Sugent, Art Milner, and Verne Pass, who probably built the airplane. *Popular Mechanics* and other magazines of the era published plans, which could be "scaled up" and used to build aircraft, like the Parasol. (SVC.)

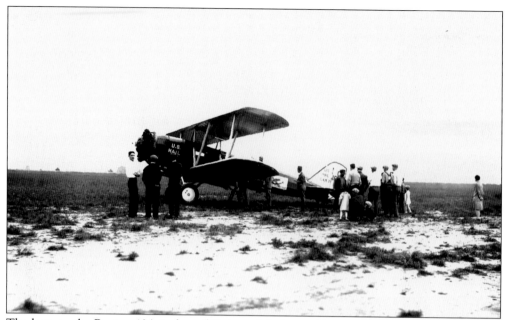

The logo on the Boeing 40A is that of Universal Aviation Company, a successor to Robertson Aircraft. The "C.A.M.2" on the tail confirms it operated through Springfield in 1928. Airmail would continue flying from Bosa/Conkling/Lindbergh Field until 1929. The 40A had enclosed seating for two passengers and a separate compartment for mail. It was the first and last Boeing "airliner" to fly regularly from Springfield, Illinois. (SVC.)

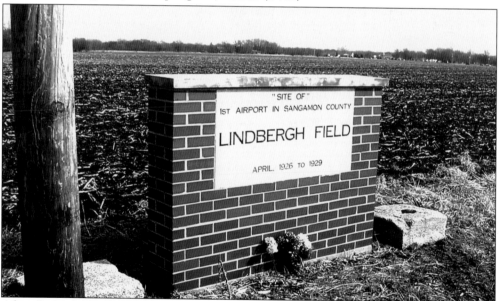

After Springfield's first public-use airfield closed in May 1929, it continued as cropland, almost forgotten. On April 11, 1995, Boy Scout Troop 11 dedicated the marker shown here, photographed in March 2008. Visitors face east, looking on ground where early aviators arrived and departed. Visitors may view this historic place by driving west on Jefferson Street, looking for the sign reading "Historical Marker Ahead," and turning north on Hazlett Road. It is located five telephone poles north on the right. (JC.)

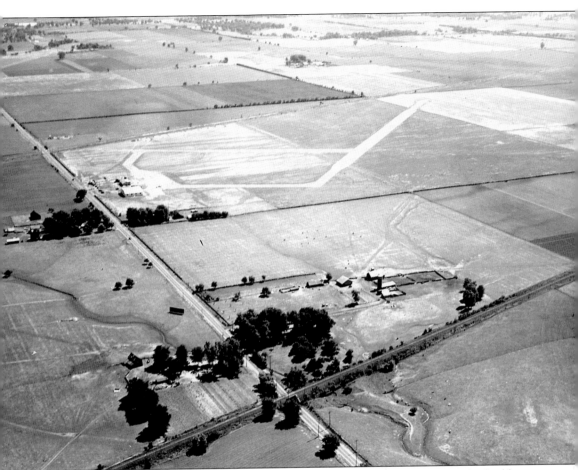

Gelder Lockwood and Craig Isbell borrowed money from a local bank to finance the building of two hangars, a fuel shed, and three airplanes when they relocated their business to the new flying field southwest of Springfield in 1928. Later city money would help. Prominent in this early view looking southwest are State Route 4 (passing under a railroad viaduct) and the primary runway running southwest, the taxiway leading to it from the hangars, and offices on the east. On the south perimeter of Commercial Field, as it was first known, are large white letters "SPRINGFIELD," placed so pilots flying south could know the city that was behind them, rather than the city ahead and northeast of them. In 10 short years, 16 airline flights would be arriving and departing from this field. In 2008, almost all acreage visible here is covered with houses. The railroad tracks are gone; only a few of the buildings built later in the airport's life remain, used for retail and storage. (SVC.)

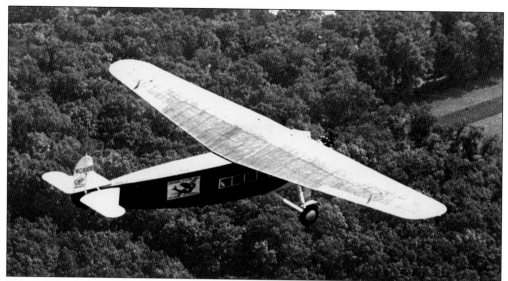

Scheduled air service from Springfield began when Robertson Aircraft successor Universal Airlines began flying Fokker Universals from Commercial Airport in December 1928. With one engine and pilots seated high in the fuselage in an open cockpit just in front of the wing, the Universal could carry four to six passengers. Until scheduled air service from what was then called Springfield Municipal Airport ceased in 1940, no airliner operating from Springfield could carry more than 15 passengers. (SVC.)

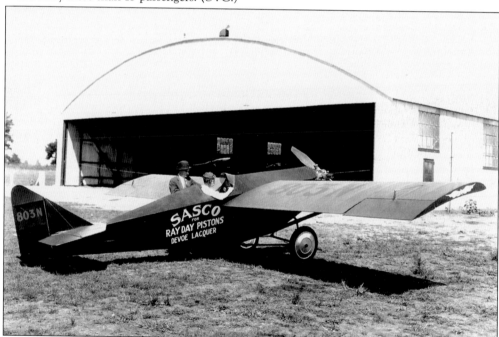

The mid-wing Ny Day Messenger (803N), photographed in 1930, was powered by a Lawrence radial engine and owned by L. G. Walling and G. W. Townsley of Springfield. SASCO was the name of an automobile parts dealer that is today just a memory. Though it is possible the plane could have been used for automobile parts pickup and delivery, the obvious limited cargo capacity suggests its primary value was as a flying "billboard." (SVC.)

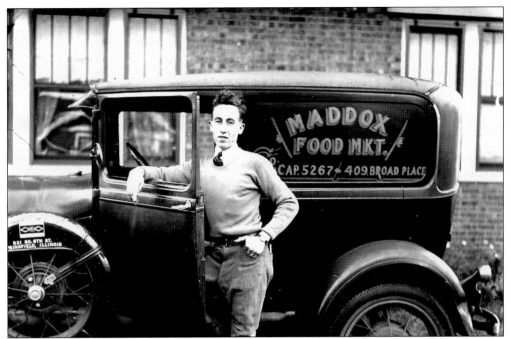

Jim Minser was a legend to those who knew him. Employed for years as a line boy at Commercial Field, a September 1930 *State Journal* reported that he was sidelined following a minor accident and delivered groceries for Maddox Food Market. Though he did not earn a pilot's license, he toured with "Crazy John," a Native American Ford Tri-motor pilot. Later he worked for North American, building B-25s; later still, for Springfield's Giuffre Buick dealership. (SVC.)

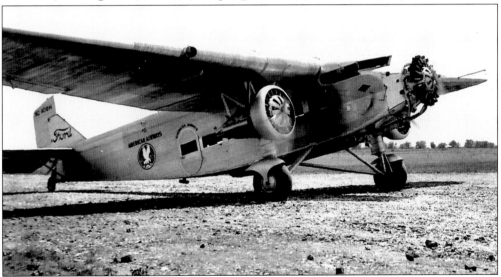

American Airways (later Airlines) began flying the metal-covered Ford Tri-motor from Commercial Field in November 1930. The Ford was not the first tri-motor, but it was the safest. A well-publicized crash of a fabric-covered tri-motor which killed football coach Knute Rockne revealed major airline safety issues, and the Ford was the solution. Three engines were used because no two engines available at the time could carry a profitable payload of passengers and cargo. (SVC.)

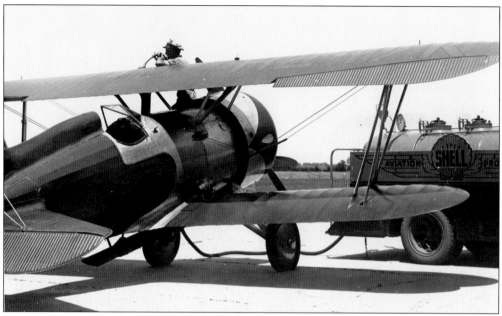

Boeing's P-12 series evolved from the F4B naval fighter with fabric-covered fuselage and ultimately an all-metal version, with wings that retained fabric covering. Simply extending an arm outside the cozy cockpit could initiate a gentle turn in that direction. A few "demilitarized" versions, sans guns and bomb racks, were sold to prominent civilians, including Art Goebel, winner of the 1927 Dole Race from California to Hawaii. He flew this machine as a sky writer. (SVC.)

Though he continued to compete in air races, became a Hollywood movie stunt flying legend, and flew for the military in the South Pacific during World War II, the infamy from the many lives lost during the Dole Race tainted a major accomplishment. These two pictures taken during a 1928 Springfield visit to Commercial Airport reveal a large windshield (likely used for cross-country journeys) bolted over a smaller one, probably used in air show performances. (SVC.)

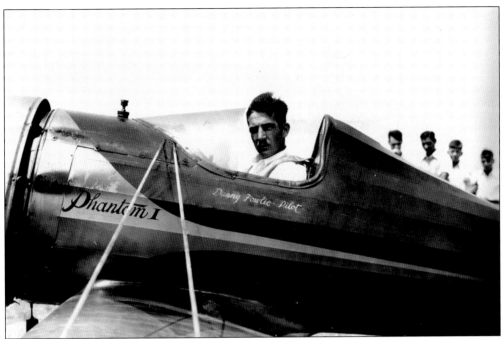

Despite the shoulder harness visible in this 1930 close-up of Nicholas Beazley Pobjoy Special *Phantom I* (R1W) air race pilot Danny Fowlie, it is highly unlikely that the young pilot was going anywhere except for a posed picture. Otherwise he would almost certainly have worn a leather helmet and goggles high on his forehead. He later became test/demonstration pilot for Flagg Aircraft of Rochester, Minnesota. (SVC.)

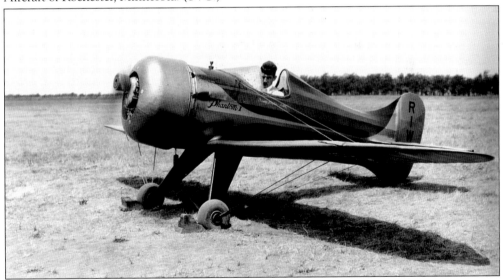

The race number 23 assigned to this airplane had not yet been applied to the fuselage, indicating he was in transit to the 1930 National Air Races in Chicago. The reduction gear on the British air-cooled radial Pobjoy engine placed the propeller higher than center, fooling casual observers. Backers anticipated the racer, built by the Pobjoy Group of Marshall, Missouri, would take first in the 200-cubic-inch category, but Fowlie placed only third. In 1932, it was purchased by race legend Steve Wittman from Oshkosh, Wisconsin. (SVC.)

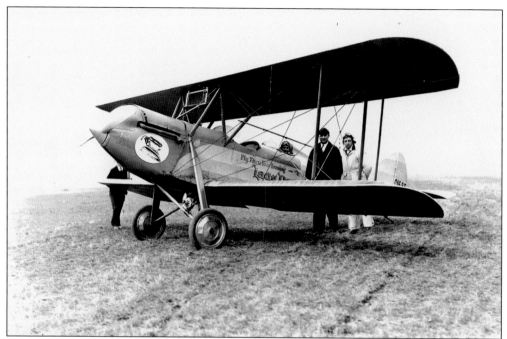

From April 16, 1928, to April 28, 1929, Craig Isbell flew L&I Aerial Service's Waco 10 *Lady Dover Iron* advertising plane from Lindbergh Field as a "hired wing," dropping advertising flyers to small Central and Southern Illinois hamlets served by Central Illinois Public Service Company (CIPS), a public utility that was modernizing much of the state with gas and electricity. Today flyers from the sky have been replaced by spam distributed from hard-charging mainframe computers. (SVC.)

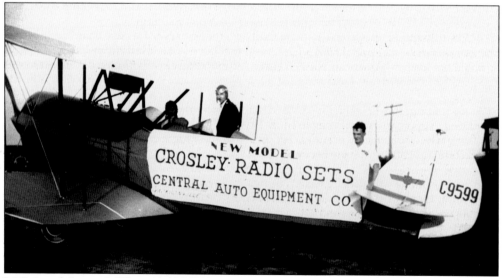

L&I Aerial Service's Waco 10 (C9599) was a real workhorse. On June 10, 1929, Isbell and a local merchant flew to Cincinnati, Ohio, and returned with a shipment of Crosley Radios. Considering how, at the time, express rail cargo could approach the expedited transport time of relatively small quantities of radios, the value of stunts like this lay in planting seeds that would take root and blossom into FedEx and other modern priority cargo carriers. (SVC.)

Three

THE GOLDEN AGE, 1931–1940

In the late 1920s through early 1930s just about any out-of-town business or "cause celeb" arriving in Springfield by air was almost guaranteed a picture and breezy story in the newspaper. They were heady times.

During October 1931, Springfield Commercial Airport installed its first landing lights, relocated from the closed Lindbergh Field. L&I Aerial Service had changed names to Springfield Aviation Company. By this time, regular airline service, begun in 1928, was being flown with Century Airlines's Stinson Tri-Motors and American Airways Pilgrim 100s.

A 1933 newspaper article urged a municipal government agency, a park board for instance, should take over Commercial Field since federal funding was not available for private airports. It would not happen. American Airways (later Airlines) had ceased operating there because of the need for improvements but returned in June 1934 and were joined soon by Pacific Seaboard Air Lines.

A new administration building with control tower, the one many remember from the Southwest Airport years, was completed in 1934. On October 20, Ameilia Earhart, financing her flying adventures with a relentless but profitable speaking tour, appeared at the Elks Club. Her lecture was entitled "Flying For Fun."

By 1937, the original 37.8 acres of airport had expanded to 160. There was talk of stationing military airplanes at the field, renamed Springfield Municipal Airport about 1936. Three years later, enthusiasm shifted into negative when American Airlines discontinued operations. Most of their flights between St. Louis and Chicago were filled to near capacity anyway, leaving few seats for locals. Expansion was limited because of railroad tracks along north and south perimeters.

By 1940, Springfield Municipal Airport had become a first class field for lightplane flying and would remain so for the rest of its life. Chicago and Southern Airlines moved out on November 10. For the next seven years, Springfield would have no airline service. With war inevitable, the field became the site of Civilian Pilot Training Program, teaching licensed pilots how to become civilian flight instructors for thousands of new recruits destined for far away places. The writing was truly on the (hangar) wall.

Myers Brothers, a large department store and office building on the northwest corner of the square, became a billboard and blessing for flyers that were Springfield-bound. In the early 1930s, a local civic organization sponsored the painting of large, simple signs pointing in the direction of the airfield. A similar sign was painted on the roof of the Springfield Federal Building, also in the heart of downtown. (SVC.)

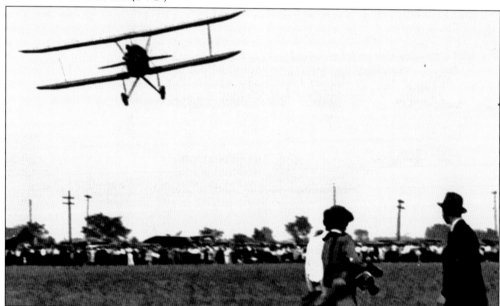

What may have been part of the shortest-lived air show event in aviation history took place October 5, 1931, at Commercial Airport. Aerial Golf involved setting a "hole" in a field, the target for pilots who would try to drop a bag of beans (probably) into the hole. The risk of one of the observers on the ground being hit by a descending bag going at least 70 miles per hour can only be imagined. (SVC.)

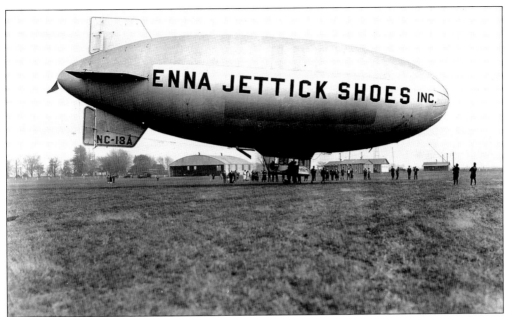

This Goodyear blimp (NC-18A) advertising Enna Jettick Shoes was in transit from Chicago to St. Louis when it encountered turbulent air and put into port at Commercial Field on November 11, 1931. This panorama in the background is a rare view of the new airport just four years old. Note the overcast sky and soft shadows on the ground. (SVC.)

During the blimp's impromptu return to earth, the crew posed for a picture. Standing are, from left to right, Lieutenant McCracken, Major Wadsworth, and unidentified. The incongruity of military men with a civil machine is obvious, but no explanation is offered on the picture notes. After the bad weather passed, the crew flew to Scott Field for minor repairs before terminating the mission in St. Louis. (SVC.)

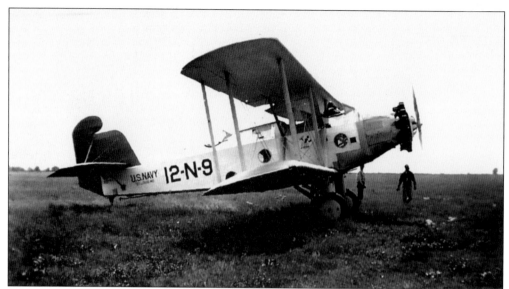

The 12-N-9 on the fuselage of this Martin T4M-1 torpedo bomber explains that it was the ninth aircraft on the roster of U.S. Navy Training Squadron 12. The unit was based in St. Louis, and this aircraft was likely on a crew training mission when photographed in 1931 or 1932. Note that the rear gunner's position, which usually carried a mounting ring for a defensive machine gun, was fitted with a third windshield. (SVC.)

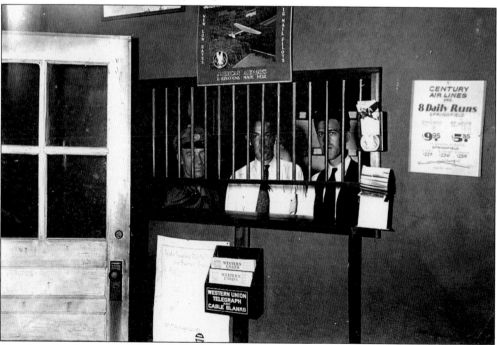

The short-lived presence of Century Airlines makes it easy to frame the date of this terminal pose in 1931. Smiling at the camera inside the ticket sales window are, from left to right, Jim Harney, an unidentified mail truck driver, and Springfield Aviation Company employee Don Whitney. The sign on the wall says "Century Air Lines / 8 Daily Runs / $9.95 to Chicago / $5.35 to St. Louis." Note also the Western Union forms for sending cables and telegrams. (SVC.)

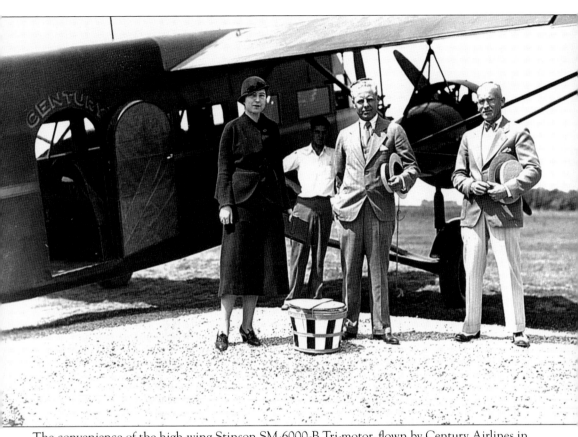

The convenience of the high-wing Stinson SM-6000-B Tri-motor, flown by Century Airlines in 1931, is evident here. Entry into the roomy 10-passenger cabin required no assistance. The picnic basket no doubt contained sandwiches, fruit, and bottled beverages for an enjoyable summer journey to Chicago. The absence of more passengers may illustrate the light loads flown by Century Airlines and explain their short-lived service to the Capital City. (SVC.)

Though it resembled the earlier Fokker Universal flown by Universal Airlines, the Pilgrim 100, nine-passenger airliner was a Fairchild design, and all were flown initially by American Airways. The pilot's view from high on the fuselage was excellent, passengers rode below, and baggage was carried under the passenger cabin floor. The large "balloon" tires helped cushion the ride, especially taxiing over rough turf. Cruising speed with a full load was 118 miles per hour. (SVC.)

The Curtiss Condor that replaced the Pilgrim 100 offered a roomier cabin, 15 seats for passengers, and two seats for the crew. In 1932 and 1933, Springfield passengers rode them not only to Chicago but also on connecting flights to New York. Comfort was unmatched in its day with an aisle height of six feet six inches, special sound proofing, reclining leather and fireproofed fabric seats equipped with reading lights, and racks for light luggage provided in the ceiling. (SVC.)

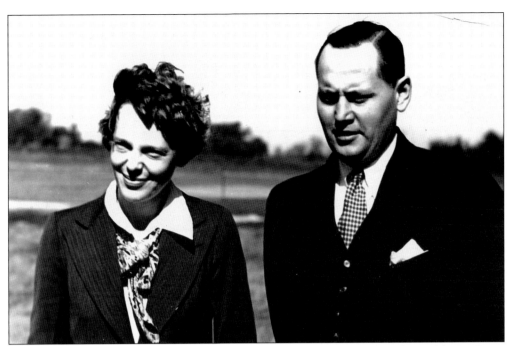

Amelia Earhart, visiting Commercial Field October 21, 1934, posed with World War I ace Howard Knotts. She was world-famous, the first woman to fly the Atlantic solo (May 21, 1932) five years after Lindbergh had flown to Paris. She had also participated in the first Women's Air Derby, which passed through Springfield in 1930. She would return once more before her tragic loss, with navigator Fred Noonan, in 1937. (SVC.)

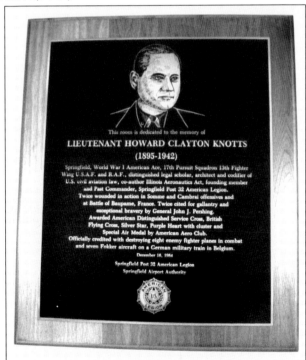

This plaque in front of the Howard Clayton Knotts Room at today's municipal airport describes a great American. The Girard native came to Springfield after completing law school. Before dying in 1942, he played a major role writing Illinois aviation law. Despite attempts over the years to name both municipal airports after him, local leaders chose another famous lawyer. On June 15, 2004, the airport was officially renamed Abraham Lincoln Capital Airport. (JC.)

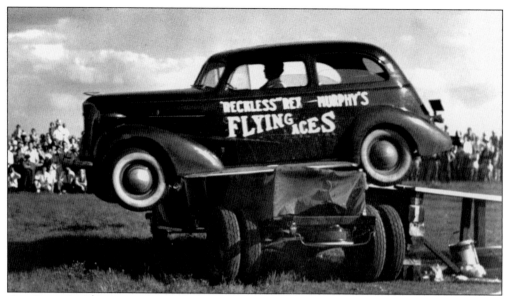

A sad paradox of aviation history is that most enthusiasts inclined to take pictures at special events are often so involved with them that they have no time to leave more pressing duties to snap away with a Kodak. This certainly appears true regarding Reckless Rex Murphy's Flying Aces air show. Antics like cars almost jumping cars provided welcome variety in a string of flying performances and drivers became almost as legendary as winged bretheren. (SVC.)

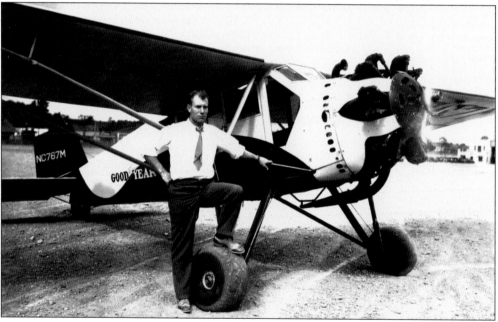

Apparent in this photograph of a Curtiss Robin (NC767M), built by Curtiss-Robertson of St. Louis and pictured at Commercial Airport in the early 1930s, is that this example was equipped with a parking brake. Otherwise without wheel chocks, the jaunty gent (no doubt a Goodyear marketing representative) posing would have been run over. Airplanes often advertised products or services well into the 1960s, but the complete custom paint for this aircraft is especially noteworthy. (SVC.)

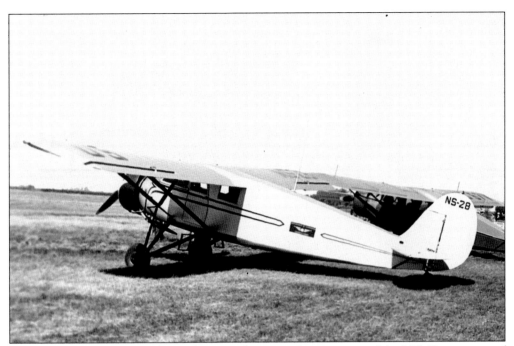

The Stinson SM-8A Junior (NS-28) carries the unusual registration of the U.S. Department of Commerce visiting in the early 1930s. Roomy for four people, easy to fly, and stout as a horse, the Junior was the most popular aircraft in its class during 1930 and 1931. It truly "set the stage" for the more elegant SR Reliant that would follow in a few years. The company merged with Piper in December 1948. (SVC.)

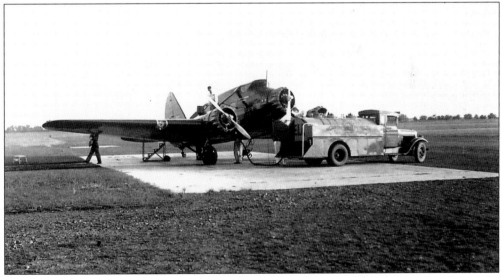

Looking like a thoroughbred at the starting gate, this Stinson Model A Tri-motor replaced the biplane American Airlines Curtiss Condors and was photographed at Springfield Municipal Airport in about 1936. With its large wing and plenty of power, the "A" could operate from smaller airfields and was liked by pilots and passengers. The service career was short, out of American's inventory in 1938 and replaced by the early Douglas DC series that could not operate from Springfield Municipal Airport. (SVC.)

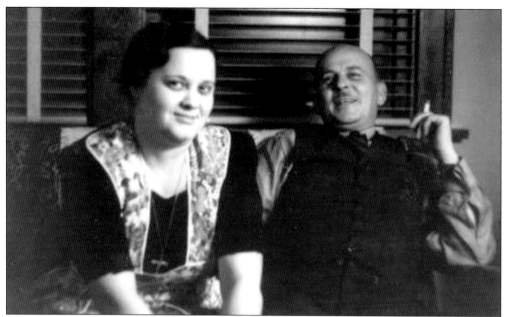

No Springfield photographer left a greater gift to future aviation historians than C. W. Chiles, pictured here with his wife, Flossie, in the 1930s. He was secretary-treasurer of the Springfield Chapter of the National Aeronautic Association. Most of the pictures donated to the Sangamon Valley Collection by Craig Isbell were taken by Chiles. He also produced an extensive portfolio of aerial photographs of Central Illinois cities and villages all maintained at Springfield's main branch Lincoln Library. (SVC.)

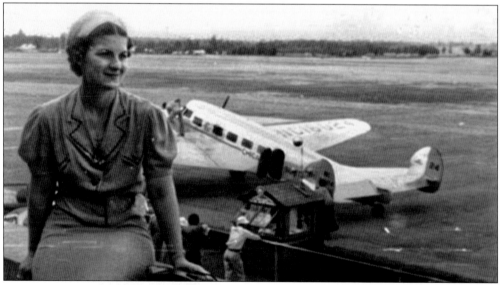

Soon after Chicago and Southern Air Lines began flying Lockheed 10 Electras from Springfield Municipal Airport, they flew invited guests on a publicity flight to Jackson Mississippi in the summer of 1937. Among them was Gerrie Walker, wife of columnist John Thornton Walker who also went along for the ride. This view shows her and Electra (NC16824) taken from the observation deck. The sleek machine was the most modern airliner to fly from Springfield Municipal Airport. (CWS.)

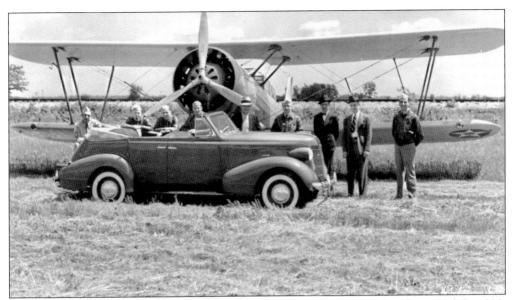

Is there a Corvette driver who would not love to have a picture posing beside an F-16? In 1938, the local Pontiac dealer arranged this occasion at Springfield Municipal Airport. The aircraft is a Douglas O-38, probably an Illinois Army National Guard machine that happened by on a training flight. The era of two-seat observation "crates" (some say "coffins"), begun in the early days of World War I, came to a screeching halt in 1939. (CWS.)

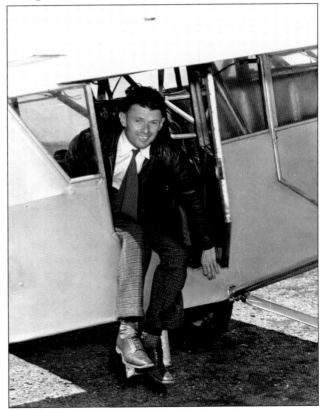

Given the failure of airport "management" to implement improvements urged by a growing chorus of citizens, it was perhaps fitting that the most famous visitor to Springfield Municipal Airport in 1938 was Douglas "Wrong Way" Corrigan on August 22, fresh from his "accidental" flight to Ireland. Corrigan helped build Charles Lindbergh's *Spirit of St. Louis* 11 years earlier as an employee of Ryan Aeronautical Company. Here he exits his Curtiss Robin (NX9243) on arrival at Springfield Municipal Airport. (SVC.)

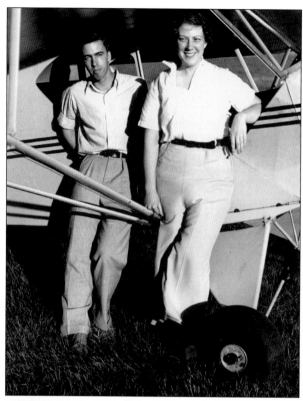

Another Springfield legend was certified flying instructor (CFI) Adelaide O'Brien, photographed next to a Taylorcraft June 25, 1937, with student Charles D. Spengler of Glenview. Springfield Aviation Company was a Taylorcraft dealer, and with its side-by-side seating, compared with the tandem arrangement of the Piper J-3 Cub, it was a popular trainer and "Sunday flying" machine. O'Brien later was a ground instructor at Springfield Municipal Airport during World War II, taught elementary school, and directed local theater productions. (SVC.)

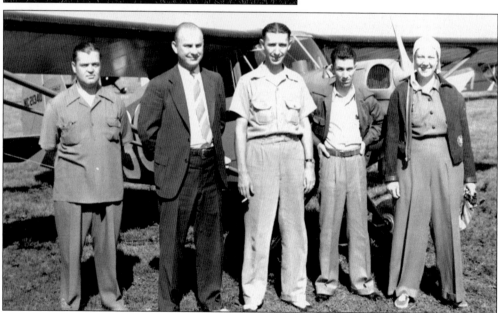

On August 10, 1939, at the Illinois Air Fair (details unknown), Springfield flyers were riding high as the darkest days of the Great Depression seemed almost history. These intrepid Springfield aeronauts in the latest flying fashions posed for the photographer. Seen here are, from left to right, Thorp Metz, Nelson Weber, C. Fred Smith, John W. Marsh, and Adelaide O'Brien. Their lives would change 21 days later, and many flying buddies would leave Springfield forever. (SVC.)

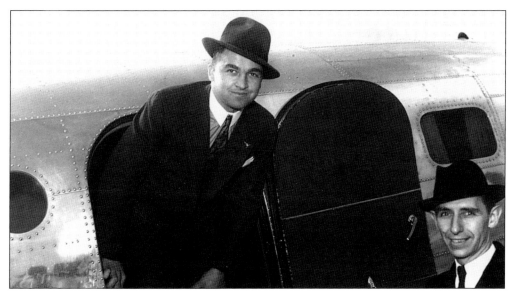

Emerging from a Lockheed Electra is Stanley Kluzek, a Springfield aviator who, in January 1939, announced his plans to fly from New York non-stop to Warsaw in May or June. His plane would be a long-range Barkley Grow twin, similar to the Lockheed Electra, named *The Abraham Lincoln*. On his right is Mayor John W. "Buddy" Knapp Jr. Due to deteriorating relations with Germany, the U.S. State Department refused to permit Kluzek's flight. (SVC.)

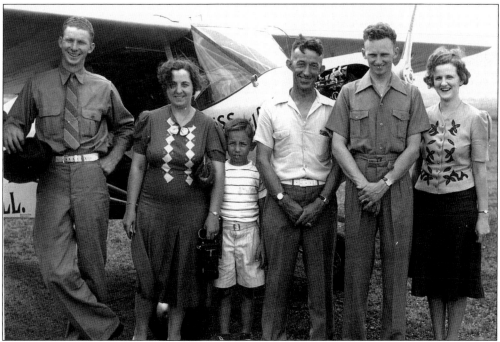

During the summer of 1939, two Dalton City, Illinois, kids with a dream and their families spent days at Springfield Municipal Airport preparing to break a world endurance record for light planes. Then they took off on July 23 and did it. Pictured here in front of their Taylorcraft named *Miss Springfield* are, from left to right, Humphrey Moody, Mrs. Wilbur Parrish, Wilbur Parrish Jr., Wilbur Parrish (presumed crew chief), Hunter Moody, and Mrs. Hunter Moody. (SVC.)

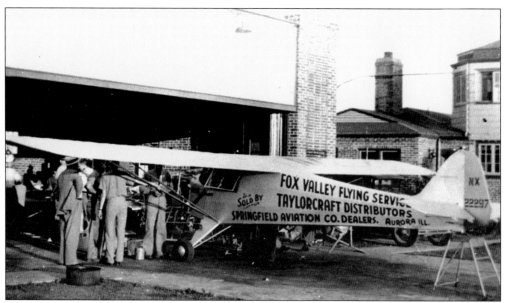

The Moody aircraft was specially equipped for the record attempt with two wind-driven generators to power fuel pumps and non-standard radio equipment; hence the NX22297 registration. Fuel would be transferred from truck to aircraft during low, slow passes down the runway. The aircraft was purchased new (details on rear fuselage) and following the successful flight, was sold back to Springfield Aviation Company. It was rebuilt, painted, and remained operational with the business. (SVC.)

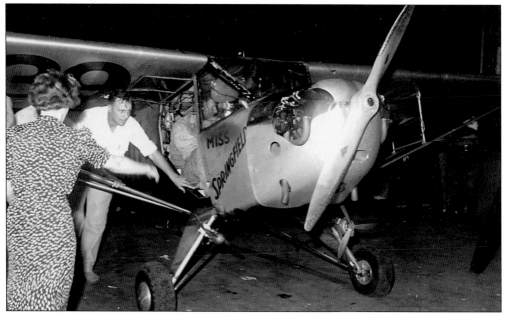

The long flight, which concluded at 10:46 p.m. on August 6, was halted not by faulty equipment but by approaching thunderstorms. Though the brothers had flown circles around Springfield for days, they could not out-run or fly over the tumultuous weather. Their flight had lasted 343 hours, 47 minutes, and 30 seconds and covered about 27,000 air miles, equivalent to slightly more than a non-stop hop around the world at the equator. (SVC.)

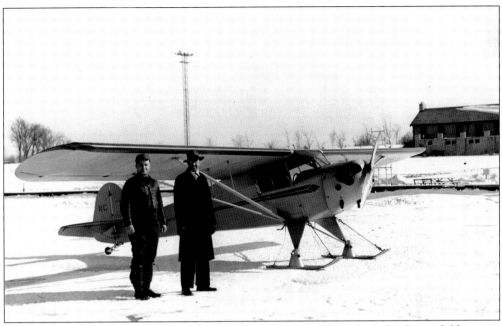

Craig Isbell is credited with making the first airplane landing on Lake Springfield ice on January 22, 1940. Pictured on that day in front of the public beach house, a structure that still operates in 2008, are Isbell (right) and Don Leland Stanford. Considering that the T-craft was a two seater, the picture must have been coordinated with a helper who drove to the scene. Such a landing today would reap a hefty fine from the FAA. (SVC.)

This late 1930s scene from the landing pattern of Springfield Municipal Airport reveals the airfield's inherent limited potential. Raised railroad embankments on north and south borders prevented the lengthening of runways and contributed to the decision to provide nothing better than crushed shale surface runways and a small concrete apron directly in front of the terminal. Only after the loss of airline service in 1940 did Springfield leaders get serious about building a better airport. (DB.)

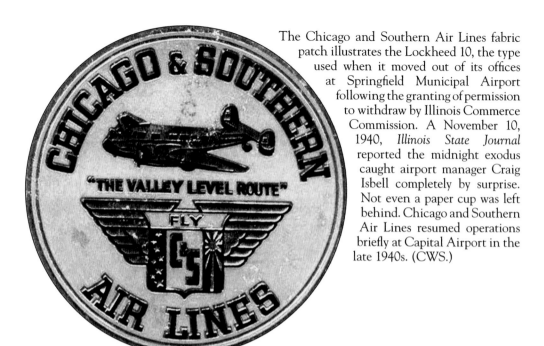

The Chicago and Southern Air Lines fabric patch illustrates the Lockheed 10, the type used when it moved out of its offices at Springfield Municipal Airport following the granting of permission to withdraw by Illinois Commerce Commission. A November 10, 1940, *Illinois State Journal* reported the midnight exodus caught airport manager Craig Isbell completely by surprise. Not even a paper cup was left behind. Chicago and Southern Air Lines resumed operations briefly at Capital Airport in the late 1940s. (CWS.)

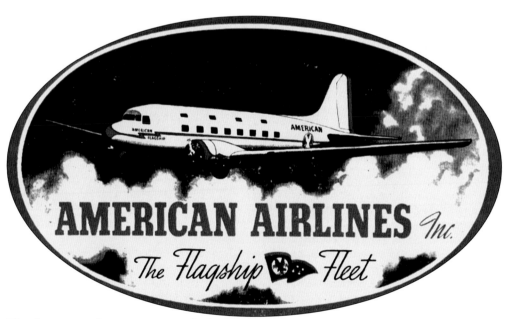

This baggage sticker was never applied to luggage exiting a Springfield airport. Early Douglas Sleeper Transport (DST) versions of American Airlines's DC-3 introduced in the late 1930s were flown on overnight transcontinental runs. The crushed shale runways at Springfield Municipal Airport damaged expensive propellers, chewed up tires, and were unsafe when standing water lingered on the uncrowned (higher in the middle) surfaces. American Airways ceased operations from Springfield Municipal Airport in 1939 and returned at Capital Airport in 1947. (CWS.)

Four

THE ALUMINUM AGE, 1941–1945

It speaks volumes for those who fought in World War II that Springfield's monument to them came after nearby monuments to Vietnam and Korean War veterans had been built at Oak Ridge Cemetery. The story of Springfield citizen contributions to the war merits far greater attention than it has been given.

With general aviation curtailed for the duration of the war, the only lightplanes flying were those involved with Civil Air Patrol and the Civilian Pilot Training Program (CPT). By the December 8, 1941, congressional declaration of hostilities the CPT had begun instructing student pilots as well as flight instructors at Springfield Municipal Airport in cooperation with ground school taught by Springfield Junior College.

Fleck's airport, located on the far south extremity of the city, had ceased operations in 1938 after a tornado wrecked it. A 1939 phone book lists Fleck's Used Cars operating from a near southeast address; no mention of the airport. As victory approached, Bud Fleck appears to have relaunched his FBO near Lake Springfield, southeast of downtown. A January 1945 directory, likely assembled in late 1944, lists Fleck's Air Park. Citizens remember a small landing strip near the Lincoln ordnance plant between the city and Lake Springfield on the east side of Route 66. It disappeared following the armistice.

In 1942, Mayor John W. "Buddy" Kapp Jr. proclaimed the existing airport was obsolete, and on June 6, 1943, Springfield Airport Authority was formed.

The June 3, 1945, *Illinois State Journal* front page editorial urged voters to approve a referendum that would have boosted citizen real estate tax 23¢ on the dollar to pay for a new airport to be built with federal assistance. Two finalist sites were selected. The first was southwest of the ordnance plant on Route 66. Walnut Street would have been extended south to serve it. Unfortunately Lake Springfield to the south was a barrier. The site chosen was north of the city on Walnut Street, land used in 1922 for the U.S. Army airmail flight. Springfield's quest for a permanent airport had come full circle.

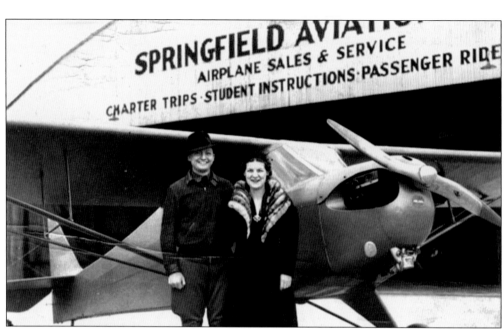

John Thornton Walker was typical of Springfieldians who went to war. Before leaving the city, he was a familiar face at Springfield Municipal Airport where he posed here with a Taylorcraft in the late 1930s with his wife, Geraldine. Both were pilots. His friends knew him as "T," his *Illinois State Journal* aviation column byline was Thornton Walker, and later military dispatches called him J. Thornton Walker. All names are almost forgotten in Springfield town. (CWS.)

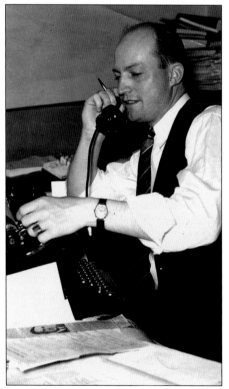

A 1931 Springfield High School graduate, Walker went to work for the *Illinois State Journal* that same year. During his time as aviation editor, he also worked as publicity director for the Illinois Department of Agriculture. He enlisted in the Illinois National Guard and was assigned to the 106th Mechanized Cavalry Squadron. There he rapidly ascended through the ranks and was a second lieutenant when the unit was called to active duty in November 1940. (CWS.)

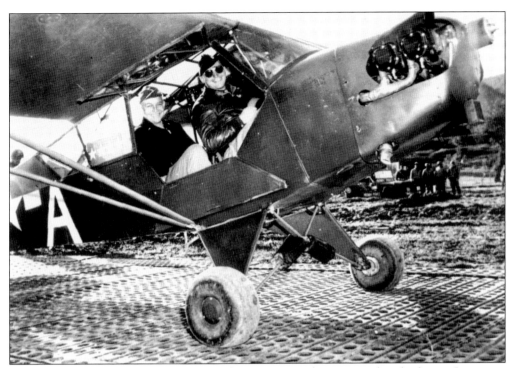

Walker's unit was sent to Camp Beauregard, Louisiana, and participated in the famous Louisiana Maneuvers in 1940 and 1941. He was directed to military flight school in late 1940/early 1941 at Barksdale Army Air Force Base in Bosier City, Louisiana, and was shipped to England and then to North Africa where he became Gen. Mark Clark's personal pilot. Visible in this Piper L-4, photographed in late 1943, are Walker in front and Gen. Dwight Eisenhower in back. (CWS.)

From the yellow border of the national insignia on the grasshopper's wings, it is clear this unique shoulder patch was crafted during Walker's service in North Africa. Newspaper articles shared by the Walker/Strouse family reveal that the "grasshopper" mission flown by Walker and others involved supplying troops with water and ammunition in addition to directing artillery fire. The pilots and aircraft at forward grass strips were in constant danger of attack by German aircraft. (CWS.)

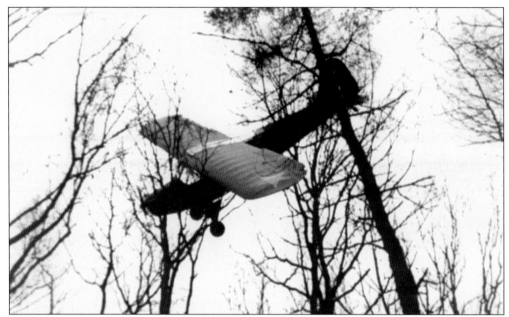

Using high altitude fighters to attack light planes may seem equivalent to shooting fish in a barrel, but it did not work that way. Aircraft like the L-4 flew so low and slowly that they were able to turn on a dime, it was hard for attackers to fire a few rounds in their direction. John Thornton Walker successfully evaded an attacking Messerschmitt by roosting in a tree. There were no injuries, and the aircraft was returned to service. (CWS.)

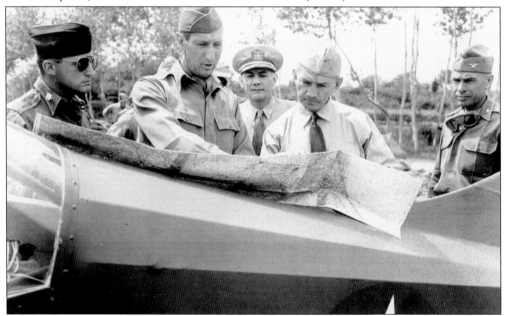

Pictured in the foreground, Walker (left) watches as Gen. Mark Clark and Secretary of the Navy James Forrestal read a map of the front lines on the fuselage of Walker's Stinson L-5 *Rome Express*. Walker had been promoted to lieutenant colonel. He previously had been awarded the Silver Star for gallantry for his action over the Anzio beachhead, in which he evaded attacks by six German aircraft to successfully complete his mission. (CWS.)

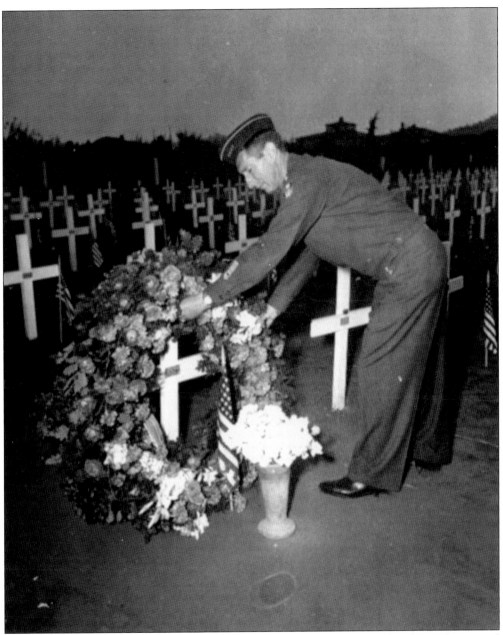

Heading home on leave, on February 19, 1945, Walker died when the Lockheed A-29 (converted for transport use) that he and other military personnel had boarded lost power taking off in Italy and crashed. General Clark, pictured here, lays a wreath at his grave in Italy. There Walker remained for several years until his remains were buried permanently in Washington, Indiana, the home town of his wife. (CWS.)

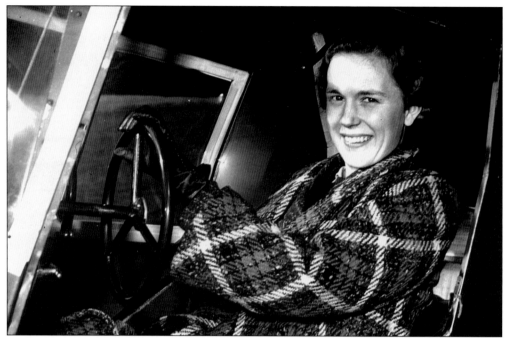

Helen Abell was a Springfield Aviation Company flying student, shown here in the cozy confines of a company Taylorcraft. She became a Women's Air Service Pilot (WASP) during World War II. She and her sisters flew almost everything in the Army Air Force inventory, allowing more mail pilots to be employed in combat theaters. After the war, she operated ran a Fixed Base Operation (FBO) in La Mesa, California. (SVC.)

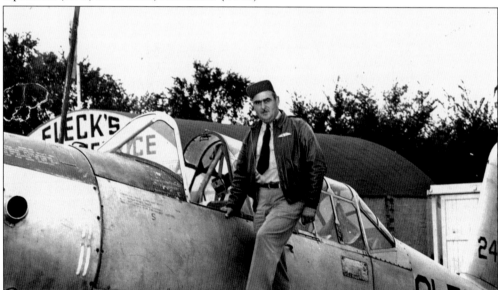

A Vultee BT-13 pilot poses during a stop at Fleck's airport on the city's southeast side close to Lake Springfield during World War II. The partial serial number, visible on the tail, confirms an active duty airplane, and the lettering on the hangar confirms the FBO. Despite restricted civil flying, organizations such as Civil Air Patrol were active. Fleck's first airport, south of the city, was destroyed by a tornado in 1938, hence the move. (GF.)

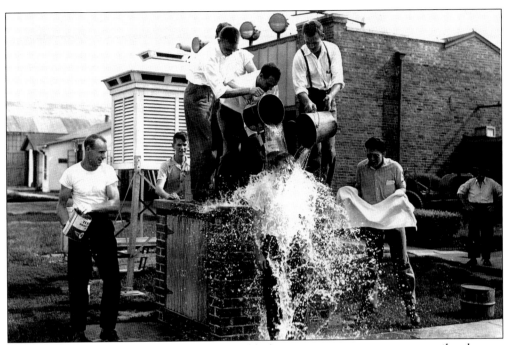

At the start of the CPT Program in Springfield, the mission was to train private pilots how to become flight instructors, who would in turn teach new recruits what today is called "ab initio" training. In 1942, the U.S. Navy Elementary Class V-5 celebrates cadet Charles R. Leigh's success with a ceremonial dousing. Pictured, dry, from left to right, are Bob Davis, Robert Fisherkeller, (unknown), James Malerich, Carl Weber, and Bud DeWall. (SVC.)

Pictured early in his career with Grumman Aircraft Engineering Company is Springfield's Corwin H. "Corky" Meyer, a CPT Program graduate. Meyer learned how to be an engineering test pilot at Massachusetts Institute of Technology. At Grumman Aircraft Engineering Company, he became Navy project demonstration pilot for the F6F Hellcat, F7F Tigercat, and more. He continued as a pilot/director of a slew of aircraft projects before retiring, for the last time, in 1992. Today he resides in Ocala, Florida. (CHM.)

Loren Jenne mastered his flying skills the hard way: by being shot at by a determined European nemesis. He went to war early. As a member of the USAAF 486th Bomb Squadron, 340th Bomb Group, the B-25 pilot helped evict Erwin Rommel from North Africa while flying under the direct command of British forces. He completed his tour under American command in Sicily and returned stateside in December 1943 with 50 combat missions logged. (LJ.)

At age 89, Jenne remembers, "The Brits served mutton but I preferred American SPAM. I *still* cannot forget the flavor of mutton, mutton, mutton." In 1964, he co-founded Slip 'N' Skid Flying Club and launched the YMCA's Flying 20 club a year later. The Mooney Mark 20 owner and CFI taught hundreds of central Illinoisans how to fly before closing his logbook for the last time in 1981. (JC.)

Five

THE PLATINUM AGE, 1946–1975

Gov. Dwight H. Green operated a bulldozer during the 1946 groundbreaking for the as-yet unnamed airport. Early the following year, there was talk of renaming Springfield Municipal Airport as Knotts Field, but politicians did not buy it. On October 21, 1947, the new airport was officially named Capital Airport of Springfield.

The pre-war Springfield Municipal Airport was renamed Southwest Airport in 1949.

Also that year, the first F-51 Mustangs were accepted by the 170th Tactical Fighter Squadron and began flying from Capital's southeastern t-hangars adjacent to the general aviation apron.

Soon after its dedication on November 2, 1947, American Airlines began flying four DC-3 flights a day. Airline operations continued in starts and stops until the arrival of Ozark in 1950. The airline would share the terminal and tarmac with American for almost a decade. Life at Capital Airport would be relatively serene until effects of the Arab oil boycott reached the city.

In 1955, Capitol Aviation, the FBO since day one, became a subsidiary of Sangamo Electric, a major industrial player and operator of a "squadron" of modern business aircraft.

A new Fairchild F-27 was probably the first turbo-prop airliner to land at SPI, a big occasion in 1959, and regular service began early the next year. An open house that year celebrated completion of a major terminal expansion.

In 1962, large Xs were painted on runways at Southwest Airport, effectively closing the long-cherished site for good, due to encroaching suburbia. The same year, American Airlines ceased flying from SPI.

Ozark commenced jet service from SPI on July 16, 1966, with Flight 967, a DC-9, which would be a familiar sight for almost a decade. The last DC-3 passenger flight departed October 1, 1967.

A new era came to SPI on February 20, 1973, when for the first time, only passengers who had been searched for weapons and other contraband were permitted into a secure passenger area. For many, it was truly the day the music died.

Sangamo Electric was purchased by Schlumberger in 1975 and by the next year, divested itself of Capitol Aviation.

Local "boys" were being nudged out of the ballpark.

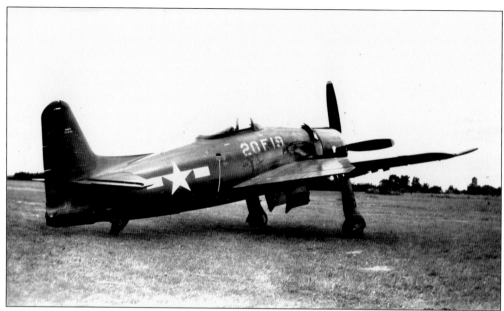

Grumman's F8F Bearcat had gone as far as Hawaii when World War II ended. It was the most capable propeller-driven air combat fighter employed by operational units during the war. One visited Springfield Municipal Airport in 1946. The field was essentially unchanged since 1940, but with a boom in light plane flying on the horizon, its future seemed secure. The Bearcat, designed for aircraft carrier deck operations, was a natural for Springfield Municipal Airport's relatively short runways (AK.)

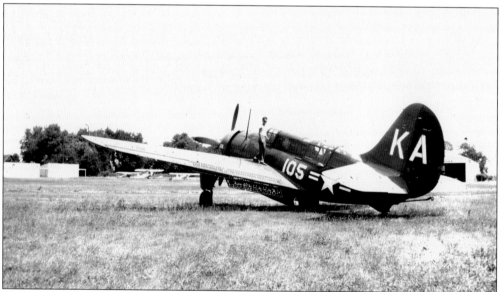

The addition of red bars to the insignia and tail codes confirm that this Curtiss SB2C-5 Helldiver visited Springfield Municipal Airport about 1947 from the Naval Reserve Base in Olathe, Kansas. Note the recently added t-hangars in the distant left. Like the large observation biplane of 10 years earlier, the two-seat dive-bomber had become an aero-anachronism, destined for swift replacement by faster, more capable single seat Martin AM-1 Mauler and the classic Douglas AD-1 Skyraider. (AK.)

How many pilots can be crammed into a publicity shot? In 1946, Springfield's "Puddle-jumper Paradise," known as Fleck's Lake View Air Park on East Like Drive, was home to many light planes. The fellow with the raised leg demonstrates the textbook stance for "hand propping" an engine to life. Since the Wright brothers first flew in 1903, this method of starting airplane motors remained much the same, despite the invention of hand crank and electric starters, complex, comparatively heavy, and expensive. Frank J. "Bud" Fleck had launched the first of his two flying fields in the 1930s on South Second Street between the lake and the Illinois Capitol Building. The location proved to be in the middle of a natural tornado corridor, so Fleck relocated the operation to the east. The field's grass runways limited its use in rainy weather, and as Capital Airport began to prosper with its expensive, tax-funded concrete runways and modern navigational aids, by the late 1940s, Fleck's Lake View Air Park's ultimate demise was inevitable. (GF.)

Though remembered most as a postwar bird, the Stinson 105 Voyager shown here posing with Dave Beatty, was a pre-war machine. Before Pearl Harbor, Stinson was rolling three a day out the factory door. Civil Air Patrol flew 75 percent of its wartime missions with the three-seat Voyagers. Beatty, a long-time professional photographer, was photographed at Springfield Municipal Airport in early 1947. He was a major presence at Fleck's Air Park as well and later at Capital Airport. (DB.)

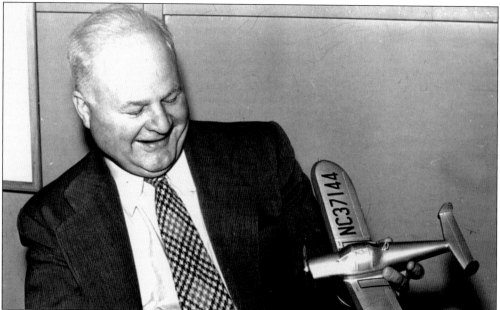

The smiling gent with the model airplane on April 13, 1945, believed he was looking at solid gold. He was, so to speak. He is Harry Agerter, sales manager for Engineering and Research Corporation, builders of a new two-seater called the Ercoupe. The airplane had no rudder pedals and was certified "non-spinnable." The innovative tricycle landing gear permitted better visibility since the pilot did not have to raise the tail to see straight ahead. (SVC.)

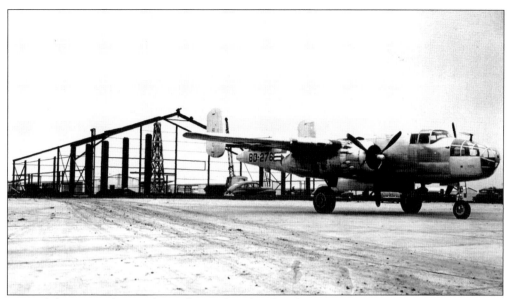

Meanwhile just northwest of Lincoln Tomb and Oak Ridge Cemetery, a vast expanse of concrete had dried, and steel was coming together at a site that did not even have a name until it was officially announced on October 21, 1947, less than a month before its dedication. The U.S. Air Force B-25 probably brought military personnel to arrange presence for the new Air National Guard unit. Hangar One goes up in the background. (DB.)

Photographed soon after the end of World War II, looking northeast, Fleck's Lake View Air Park's "demise warrant" was a fait accompli folling the completion of the new airport. Getting there on a winding drive around the northern edge of Lakr Springfield on two-lane asphalt, took almost quadruple the time required for Capital Airport and about triple compared to the renamed Southwest Airport. Acres of clean concrete closer to home easily trumped sometimes soggy turf. (DB.)

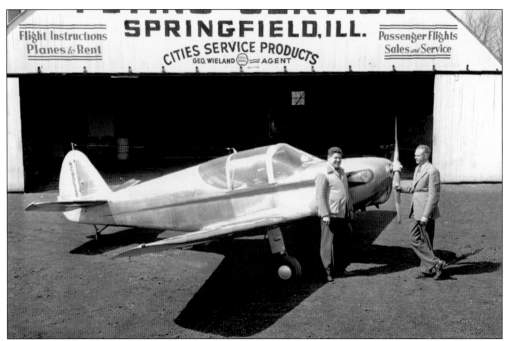

Resembling thousands of sleek fighter planes flown to victory in World War II, Globe's Swift offered two seats and a choice of 85-horsepower or 125-horsepower engines. The type was one of the first true post-war offerings to hit the market but it saw only limited success because of poor crosswind handling and modest performance. This example (NC80520) was photographed at Fleck's Lake View Air Park in 1947. A new technology version is slated for production in 2008. (DB.)

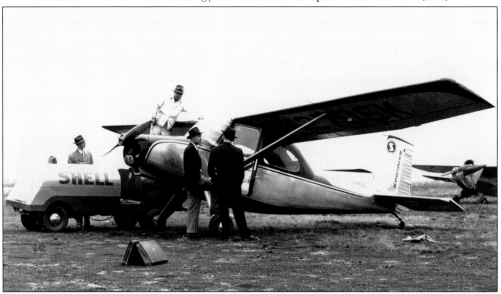

The Luscombe Silvaire Sedan was designed with flying farmers in mind, so it was only natural for the second prototype (NX2705K) to visit the heart of the nation's corn country four months after its public unveiling. Taking on fuel at Fleck's Lake View Air Park on November 3, it attracted the attention of local pilots, seen here, from left to right, Charles Pride, Ed Bernahl, R. Sebring, and Phil Bisch. The announced price was $6,995, F.A.F. (Fly Away from the Factory) from Dallas. (DB.)

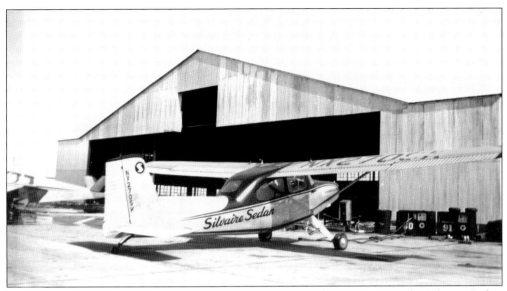

The day before it appeared at Fleck's Lake View Air Park the same Luscombe Silvaire Sedan (NX2705K) was photographed in front of the not-yet-completed Hangar One at Capital Airport. Astute observers have already noticed that the name of the airplane emblazoned on the rear fuselage did not appear on it 24 hours later at Fleck's Lake View Air Park. It may have been painted only on the right side of the fuselage. The reason for the change is unknown. (AK.)

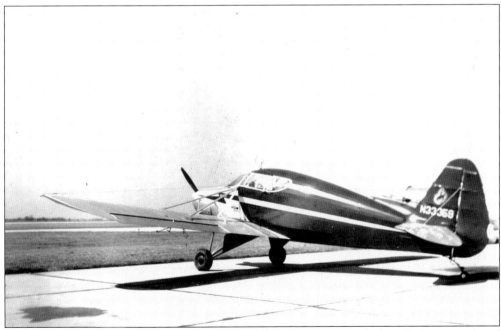

This factory-fresh CallAir A-2 (N33359) on Capital Airport's ramp in the late 1940s was produced by the Call family of Wyoming. It was a three seater, designed to operate from short, mountain rancher/farmer fields. Its ability to fly bulky, heavy supplies into 1,500-foot strips and stalling speed of 45 miles per hour could not be touched by the competition. The low wing, advertised as providing a "cushioning effect" when landing, was unusual for a short-field airplane. (AK.)

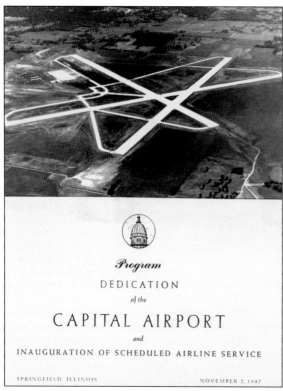

The official dedication program for Capital Airport, dated November 2, 1947, marked the official commencement of operations from Springfield's first facility with concrete runways and the reinstatement of American Airlines service from the city almost eight years to the day after unceremoniously departing Springfield Municipal Airport in 1939. The photograph on the publication's cover looks southeast toward the city. It was probably taken in early 1947 and shows few t-hangars, a nearly completed terminal, and finished runways. (SAA.)

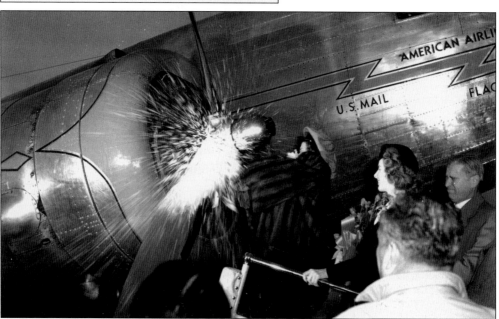

The official "christening" of the first American DC-3 to fly from SPI was delayed almost an hour when it was discovered no one had painted "Flagship Springfield" on the nose of the airplane. As soon as the paint was set, Mrs. Charles E. Becker did the deed. The event was attended by 6,000. Fred Schillt bought the first airline ticket sold at Capital Airport. His daughter JoAnn and 18 Springfield passengers flew to Chicago. (SAA.)

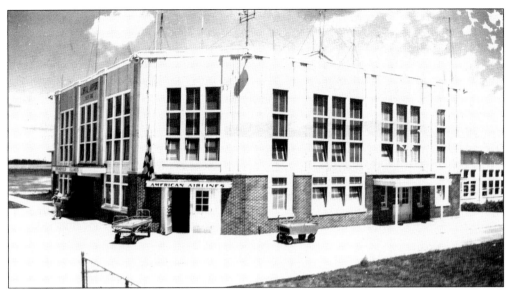

Capital Airport's first terminal building is pictured in the late 1940s. Note the baggage carts by the American Airlines service door. Passengers entered and exited the terminal through the door on the left. Upstairs of the airy two-story facility contained airport administrative offices as well as a weather bureau and flight plan reporting office. The center of the second floor was open, permitting a view of the airline ticket sales and waiting area below. (AK.)

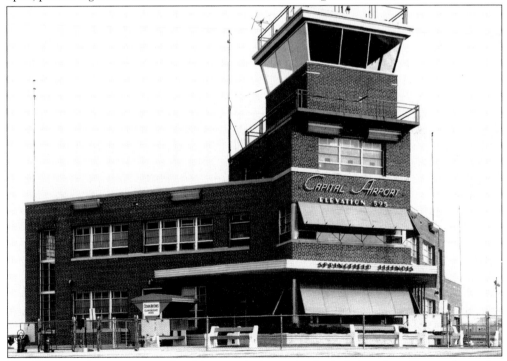

The SPI control tower just north of the terminal contained administrative offices and meeting rooms. After a new tower was built on the west side in the 1980s, some of the original walls, extensively remodeled, remained. The benches just inside the fence were popular with weekend visitors who liked to watch the big birds come and go. (DB.)

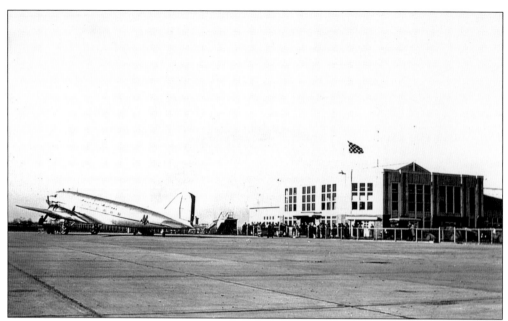

An American Airlines DC-3 prepares to depart SPI about 1950. The tall, wheeled boarding ramp nearby suggests American Airlines had begun flying their hot new Convair 240s from the airport at the time, and the ramp was used for that and other large transports. (AK.)

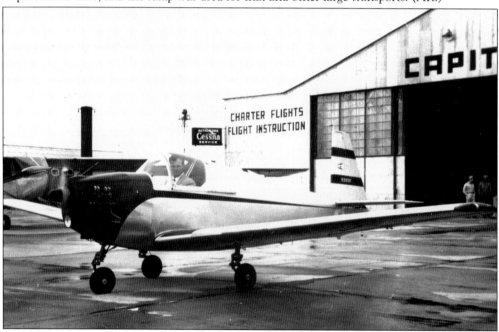

This Mooney M-18L Mite (N3165) with lucky owner/pilot aboard, is shown with its Crosley engine ticking happily away, departing Capitol Aviation about 1950. This aircraft, the ninth of the type built, came off the Mooney assembly line in 1949. The airframe is still intact, engineless and stored in a Montoursville, Pennsylvania, hangar. The Mite, a single-seater with retractable landing gear and swept-forward vertical stabilizer, was one of the most aerodynamically efficient airplanes ever built. (AK.)

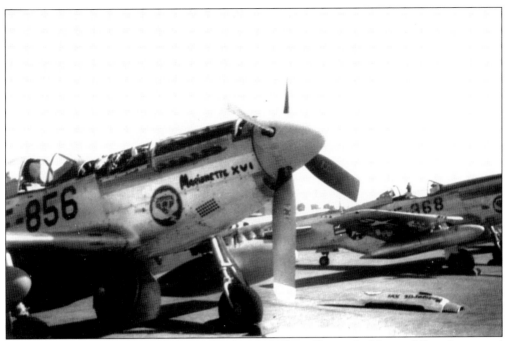

In 1948, the newly-formed 170th Tactical Fighter Squadron, Illinois Air National Guard, accepted its first North American F-51 Mustangs, formerly designated P-51s. Initially they were based on the airport apron's southeastern edge. *Marionette XVI* in the foreground carries the older World War II–era fuel tanks, while the newer Fletcher tanks hang from its neighbor. (AK.)

This is a rare candid of the 170th Tactical Fighter Squadron, about 1949. These three Mustangs are aircraft in transition from early to current markings (473556 in the foreground) and a real surprise, an RF-51, a reconnaissance version probably just arrived from an air force unit. Note the camera window behind the insignia. The replacement rudder, with half of what may have been a tail number from another Mustang, prevents confirmation of 413030 as the serial belonging to this airplane. (DB.)

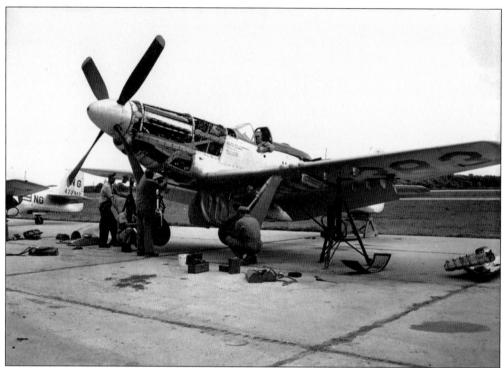

Outside maintenance, including landing gear retraction testing, was routine, especially since the ramp, shared with light planes and airliners, was the only concrete one available to the 170th Tactical Fighter Squadron in 1949. Open engine hatches on 383 indicate multi-tasking before the word was invented. The short stubs on the bottom of the wing were mounts for air-to-ground rockets, standard issue for combat training in an era when the new jet fighters were entering the air force inventory. (DB.)

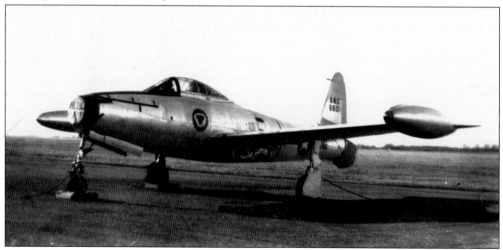

The first jet to "join" the 170th Tactical Fighter Squadron would never fly with the outfit. This Republic F-84B (6601) was delivered from George Air Force Base about 1950, to introduce maintenance crews to the new world of turbojet engines. As pilots continued to fly Mustangs, transition to jets was considered imminent. The start of the Korean War in 1950 put those plans on hold. Later versions of the Thunderjet excelled as fighter-bombers during that conflict. (AK.)

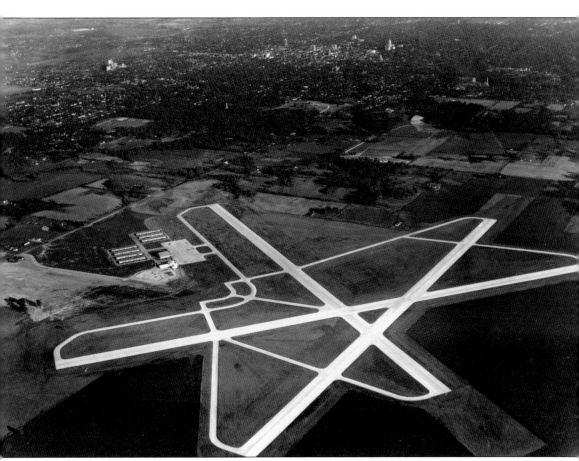

This view of SPI, taken in 1949, shows work on the 170th Tactical Fighter Squadron's new headquarters well underway behind the general aviation facilities. By this time, all the t-hangars had been built, the terminal was going strong, and the control tower construction was almost complete. The city of Springfield is visible southeast, to the upper right, in this view. The same land, somewhat less developed, had been the site of a 1922 airmail flight. (SAA.)

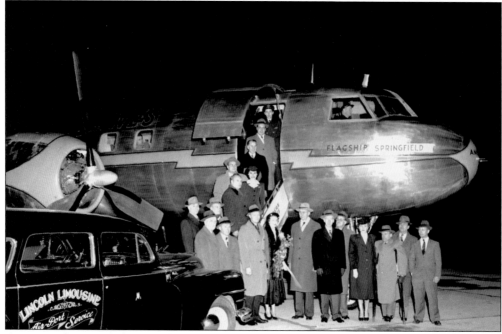

A new airplane earned a new christening. In 1949, American Airlines began service from SPI using their hot new Convair 240 (NC94222), also named *Flagship Springfield* and officially welcomed by 1948 Beaux Arts Ball Queen Cecine Cole. The owner of Lincoln Limousine "Air-Port Service" would play a prominent role in the development of early air charter operations in the years ahead. The 240 cruised at 270 miles per hour, more than 100 miles per hour faster than the DC-3. (DB.)

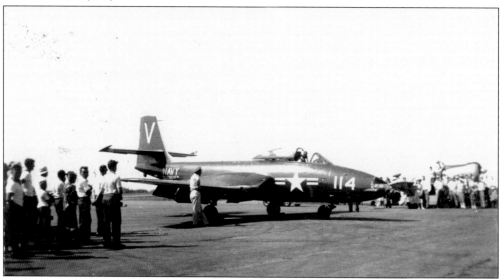

In 1952, SPI held an open house that included this McDonnell F2H-2 Banshee flown in from St. Louis. The author's first air show memory was holding onto his dad's hand as officials tried to move people away as the pilot prepared to start his engines and depart. When the first engine began to spool up and fuel was introduced, the crowd needed no further exhortations and moved as one wave away from the airplane. (AK.)

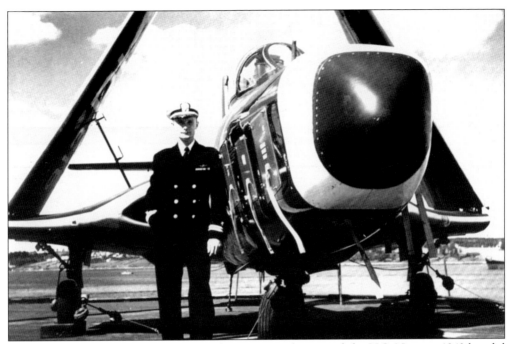

Former Springfield newspaper photographer Ken Boecker joined the U.S. Navy in 1943 but did not complete pilot training in time to see combat. What he had done on the ground, he learned to do from 40,000 feet in the cockpit of a McDonnell F2H-3P Banshee. He posed for this picture in January 1953 during his last full day with the U.S. Navy. He flew three and a half more years with the local Navy Reserve Squadron at Capital Airport. (KB.)

Driving south on Illinois Route 4, one encountered this sign before turning right into the parking lot of the recently renamed Southwest Airport. That is the name remembered by most Springfieldians to this day. There had been some talk reported in the newspapers about renaming it Knotts Field, in honor of the pioneering World War I ace and Springfield attorney. A special marker was recommended instead, but none was created at Southwest Airport. (DB.)

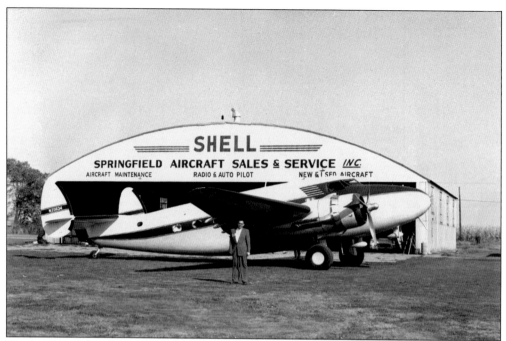

The largest airplane known to have flown from Southwest Airport or its earlier versions was this Lockheed Learstar (N25634), photographed about 1956. Based on the military PV-1 Ventura patrol bomber, most examples of this aircraft were used as executive transports. Faster than DC-3s and Beech 18s but less expensive than modern airliner conversions and equipped with the latest radios and navaids, Learstars and their smaller but similar Lodestars were popular aircraft through the 1950s. (DB.)

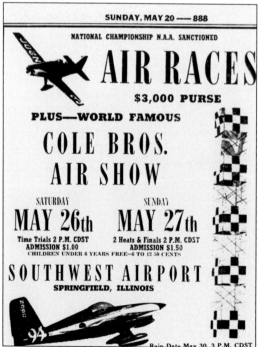

This newspaper advertisement for the last major air show at Southwest Airport also announced the only midget race event to take place in Springfield. Sponsored by the junior chamber of commerce and Springfield Aircraft Sales and Service (formerly Springfield Aviation Company), the Cole Brothers Air Show was a nationally known family package that included Duane Cole, who would return to Springfield 27 years later to fly his clipped-wing Taylorcraft at the 1983 Springfield Air Rendezvous. (DB.)

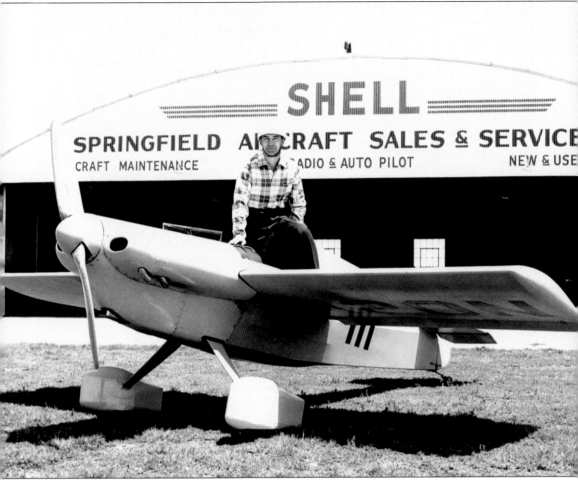

Tom Cassutt in his *Cassutt Special* placed third in the May 27 final heat behind winner Bill Falck, flying *Rivets*, and Steve Wittman, flying *Bonzo* to second place. The midget racers each spanned about 16 feet and were powered by 85 horsepower engines. They flew the 2.5-mile oval at speeds up to 200 miles per hour for a $3,000 purse. The air show included performances by Bill Adams, M. Torrance, a "long spin," and a comedy act. (DB.)

Perhaps the rarest bomber converted postwar for executive use was the Douglas B-23 (N777LW), shown here receiving a new interior and other upgrades by Capitol Aviation in the early 1950s. Only 38 of the type were built, starting in 1939, and even though left in the dust by the B-25 and B-26, they flew west coast anti-submarine patrols. Later they were used as trainers and transports. Conversions were elegant but served the civil sector only briefly. (SAA.)

In a sight seldom seen outside a warbird restoration facility since the 1960s, Capitol Aviation employees service radial engines used on larger converted bomber-type transports in the early 1950s. If one flew a Lodestar, a converted B-23, or similar aircraft, these gentlemen were their best friends (or deserved to be). (SAA.)

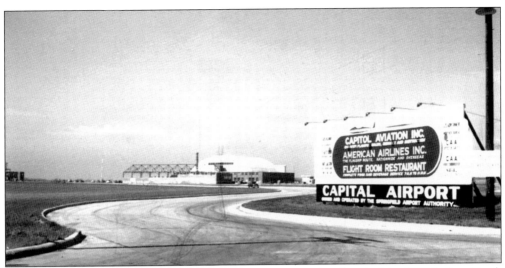

This view of the entrance to Capital Airport captures a brief period in 1950 before Ozark Airlines began flying DC-3s and after Chicago and Southern Airways discontinued its service. The new Flight Room Restaurant, added as a "wing" to the terminal, looked out on a flight line busy with traffic on sunny days. The burgers and cokes were never tastier than when shared in the company of indulgent dad during Sunday visits to the airport. (SAA.)

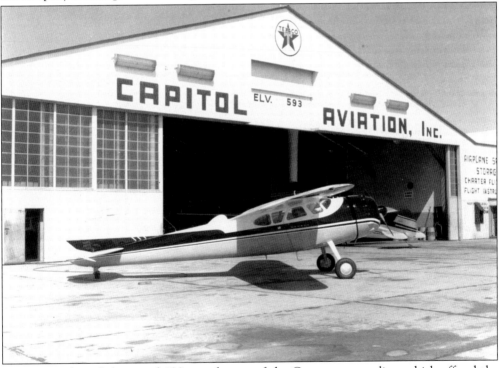

Cessna's Jacobs radial-engined 190 was the top of the Cessna postwar line, which offered the two-seat 140, four-seat 170, and 190 before 1950. As they left the factory, Cessnas were finished with minimal painted trim that included a Cessna logo on the tail over highly polished aluminum. This example (N9800A) was custom-painted by Capitol Aviation and photographed by Hangar One. The speedy 190 was flown by two Springfield charter operators in the early 1950s. (SAA.)

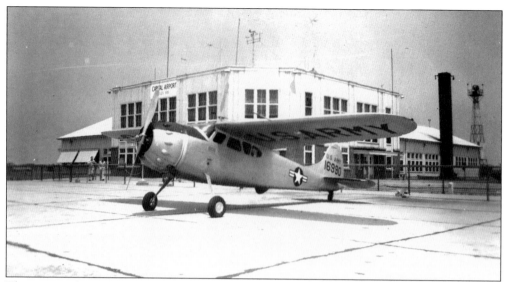

The improved Cessna 195 design flew "in uniform" with the U.S. Air Force and U.S. Army as "brass transports." This army example (16980), likely waited while upper management visited nearby Camp Lincoln. The cruising speed of 140 miles per hour provided by the 300-horsepower Jacobs was fine for short range travel, and the view, unobstructed by external wing braces, was fine except during takeoffs and landings when the big round engine got in the way. (AK.)

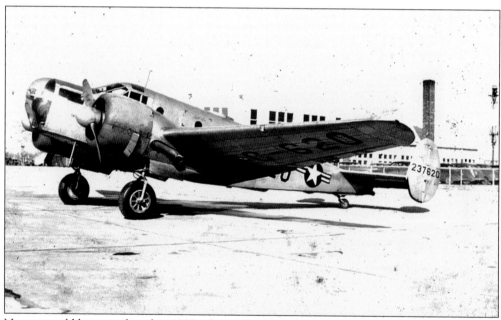

No one could have predicted in 1937, when it first flew that Beechcraft's 18 (to become known worldwide as the "Twin Beech"), would remain in production for 32 years. During World War II, many were built to train bombardiers and designated AT-11. After the war, many soldiered as courier transports for Air National Guard units, including Springfield's 170th Tactical Fighter Squadron, shown here in 1948. Though it retained the Plexiglass nose, the associated bomb gear was removed. (AK.)

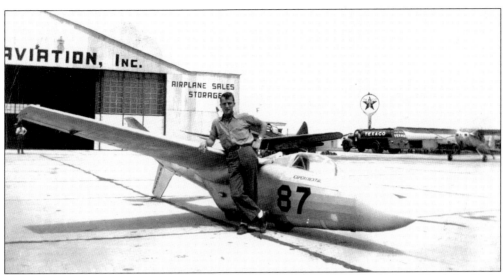

The P.A.R. Special (N90522) midget racer was designed by George Owl and built by Parks Alumni. It was trucked to Capital Airport for test flying in 1950. The glider-like landing gear was almost flush with the belly. With its mid-fuselage-mounted engine driving, the propeller at the extreme tail via an extension shaft, and variable-incidence wing that was tilted up during takeoffs and landings, it suffered more than its share of development problems. (AK.)

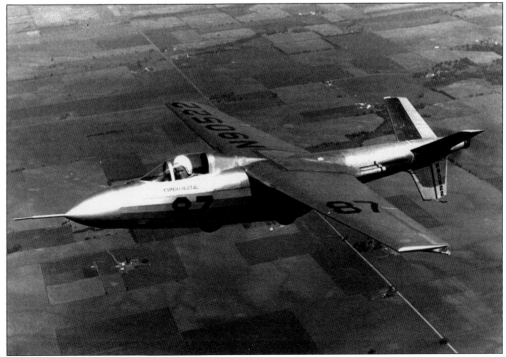

With its wing acting as a large flap, the fuselage remained level when departing and returning to terra firma. A national reference publication that states the airplane never raced also notes that pilot Art Beckington placed fourth in a Chattanooga, Tennessee, race in July 1950. The variable incidence wing feature, used first on No. 87, would be employed by Chance Vought Aircraft in their F8U Crusader carrier-based supersonic fighter. (AK.)

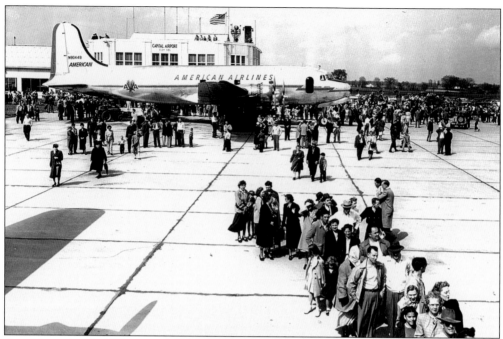

At a November 2, 1952, open house, American Airlines flew in an all-cargo-configured DC-4 (N90448) and a DC-6. This picture was taken from the top of the entry ramp to the latter as visitors waited in line for a tour. Though aviation promoters predicted scheduled service from the "big boys" like the DC-6 and Lockheed Constellation, no four-engine airliner flew scheduled service from SPI. Routes have remained, almost the same—to St. Louis and Chicago—since 1930. (AK.)

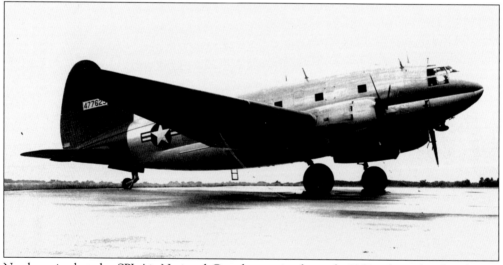

Newly arrived at the SPI Air National Guard ramp in the early 1950s, the red tail and wing tips of this Curtiss C-46 Commando indicate recent duty in Alaska. The Commando was a major participant in "Hump" operations in World War II, the effort that flew sustenance over the Himalayan Mountains to Chinese allies. Despite greater cargo lifting capability and speed than the smaller Douglas C-47, the Curtiss served only briefly with the 170th Tactical Fighter Squadron. (AK.)

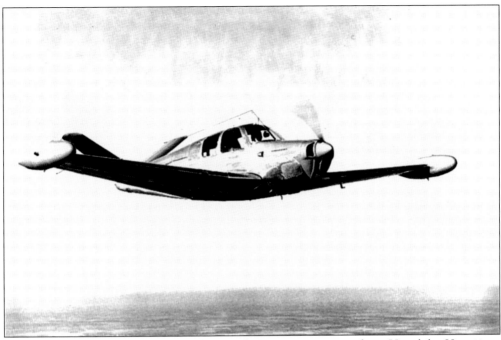

In 1949, race pilot Bill Odom flew this Beech Bonanza non-stop from Honolulu, Hawaii, to Teterboro, New Jersey. Most history books say the flight ended in New York because people know where New York is, and Teterboro is just across the Hudson River. After the flight, the Bonanza (NC80040, called *Old No. 4*), the fourth one off the production line, was donated to the Smithsonian Museum. It came out of storage for a special flight. (BA.)

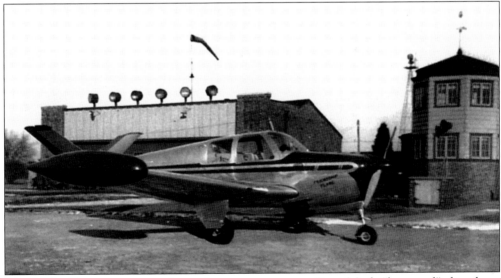

World War II navy veteran pilot and new congressman Peter Mack "borrowed" the plane, named it *Friendship Flame*, and flew it on a leisurely good-will flight around the world, sponsored by Springfield citizens and friends. It departed Springfield on October 7, 1951, and returned January 27, 1952. The *Friendship Flame* was photographed two days later at Southwest Airport. Now hanging from the ceiling at National Air and Space Museum in Washington, D.C., it bears no trace of Mack's epic flight. (SVC.)

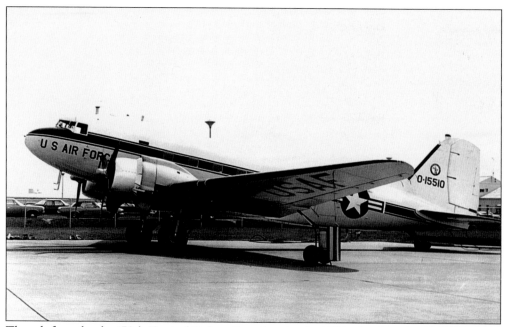

Though flown by the 170th Tactical Fighter Squadron in the 1950s, this Douglas C-47 (0-15510) was photographed late in its career, before it was replaced by a Convair CT-29. Following the first large order in 1940, the type was in continuous production in one form or another until late 1947. There were 10,654 C-47s, DC-3s, and derivatives built. This airplane departed SPI on June 1, 1973, for Hurlburt Field, Florida. Today it is on display there, repainted to represent an AC-47. (183rd FW.)

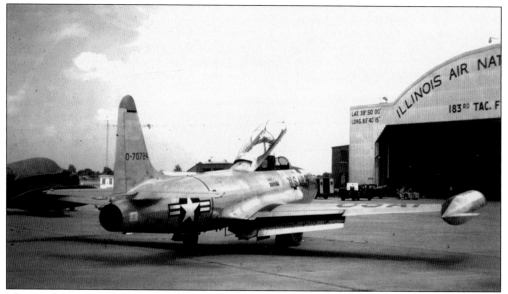

The 170th Tactical Fighter Squadron welcomed its first operational jet, a Lockheed T-33, 29454, on November 10, 1953. The newspaper reported that it was the first tactical unit of the Illinois Air National Guard to receive a jet. This late 1960s example (0-70724) was ready for proficiency flight, perhaps to shoot touch and goes. The T-33 had the acceleration of a Soap Box Derby car on a shallow hill but once airborne was a delight to fly.

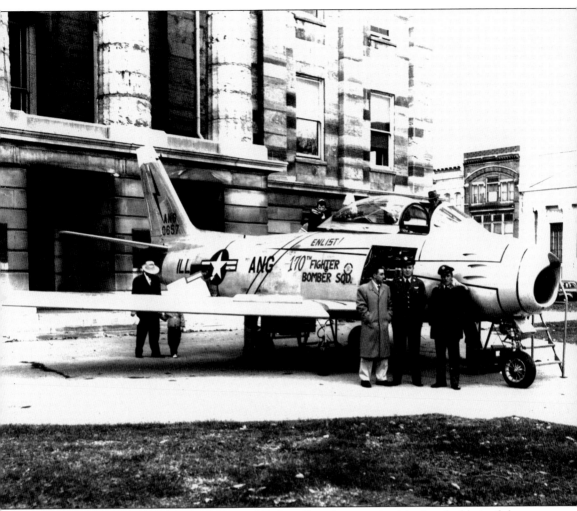

On November 18, 1953, the 170th Tactical Fighter Squadron received its first flyable jet fighter, North American F-86E Sabre (22874), colloquially known as the "Sabrejet." The type had proven its superiority over the Soviet-built MiG-15 in combat over Korea. Its arrival coincided with a recruitment drive. This example was towed to the downtown square and attracted lots of attention. The type began phase out from the 170th Tactical Fighter Squadron in early 1955. (183rd TFW.)

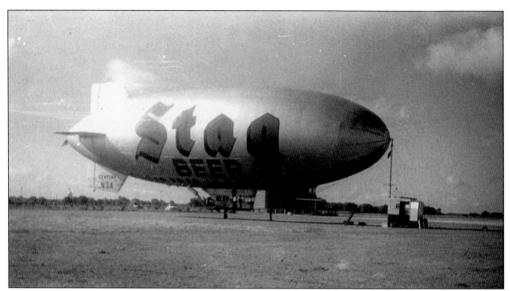

The Goodyear blimp *Century* (N3A) visited SPI in the early 1950s and was moored between the control tower and the Air National Guard facilities. With the large beer logo on its sides, the blimp cruised above the Illinois State Fairgrounds during the annual event (which did not permit beer sales on the grounds) and the rest of the city (which did). This picture was taken by the author's father and aviation mentor Job C. Conger III. (JCIII.)

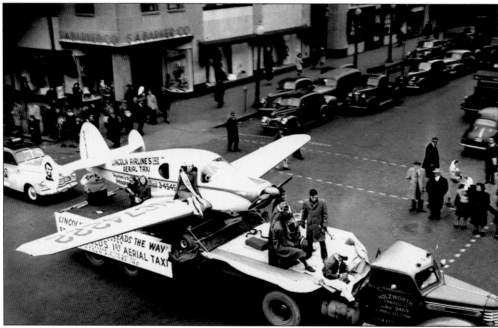

This Bellanca Cruisemaster (NC74222) of Lincoln Airlines was part of a parade through beautiful downtown Springfield in the early 1950s. Founded by Orresto "Ernie" Antonacci, the Yellow Pages advertisement urged customers to "make arrangements in advance whenever possible." The retractable gear four-seater had a wooden wing, an anachronism at the time. A radiant "Miss Lincoln Air Taxi" beams to the crowd, perched on the leading edge of the wing. Lincoln also flew a Cessna 195. (DB.)

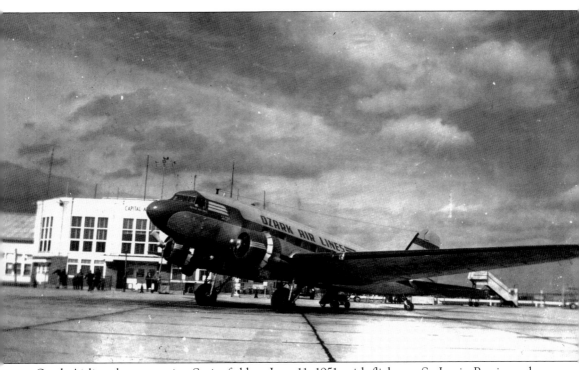

Ozark Airlines began serving Springfield on June 11, 1951, with flights to St. Louis, Peoria, and Rockford, and remained firmly planted for decades. The parked baggage cart and idle starboard engine on the opposite side of this DC-3 (N17340) confirms the airplane's visit to the ramp was brief. Competitor American Airlines's sleeker Convairs were never replaced in SPI service, but Ozark Airlines upgraded its equipment four times at SPI. (AK.)

Sangamo Electric, a major manufacturer of electronics components and owner of Capitol Aviation at SPI, owned a respectable stable of flying machines. Photographed around 1958–1959, probably from the top of Hangar One and displaying instantly recognizable colors, their Beech 18 (N39U) is sandwiched between their two Lockheed Learstars (N19L and N29L). The frequent appearance of twin rudders on twin-engine aircraft gave pilots more rudder control during challenging "engine out" flying. (JH.)

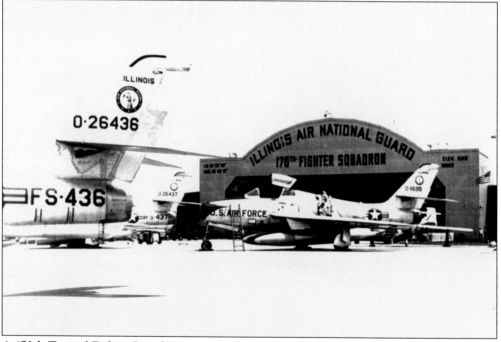

A 170th Tactical Fighter Squadron crew chief once remarked to the author that if the U.S. Air Force had added an afterburner to Republic's F-84F Thunderstreak, the bird would have gone supersonic easily. It would have also prevented the sleek bird from acquiring the sobriquet "hog," short for groundhog, which applies to the design's reluctance to leave the ground. The unit was the first Air National Guard unit to be equipped with the bird. The first arrived February 2, 1955. (183rd FW.)

This official U.S. Navy photograph captures the sleek lines of the Grumman F11F-1 Tiger, which dazzled thousands during their October 1959 performance at an SPI open house. The occasion was the completion of a terminal renovation that included a new observation deck. The Tiger's short range and limited all-weather operating capability led to their rapid fleet replacement by Vought F8U Crusaders. They served with the Blue Angels from 1957 through 1968. (USN.)

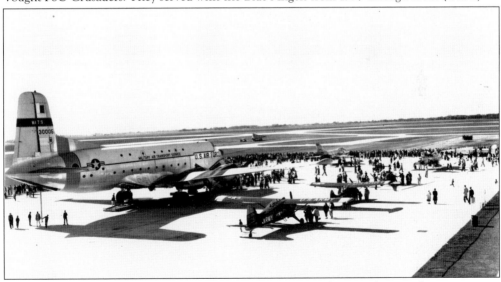

Also on hand at the 1959 open house and visible in this photograph were the centerpiece, Douglas C-124 Globemaster (30005), Cessna L-19, de Havilland L-20, Republic F-84F, and McDonnell's F-101B Voodoo. Consistent during early events were the variety of aircraft displayed and lack of tents and catered VIP seating. The first serious effort to raise local community charity funding via heavily vendored air shows would come with a bicentennial extravaganza 19 years later. (SAA.)

Capitol Aviation welcomed visitors to its facility November 23, 1957, where they showed off the revolutionary Cessna 172 that had just entered production. Also on hand was a custom-painted Cessna 180 and education exhibits that explained the many services offered and extolled the value of general aviation to the public at large. This picture was taken before the doors opened to eager visitors. (SAA.)

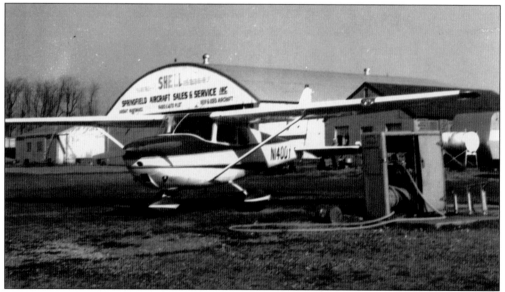

On a sunny afternoon in November 1962, the author snapped a picture of this Cessna Skyhawk (N1400Y), a deluxe, painted version of the 172 and more modern with the new swept vertical stabilizer. The pilot offered a ride. During the taxi to the runway, it was determined that without parents' permission, a flight in this machine was forbidden. It was the author's first and last opportunity to fly from Southwest, and the long bike ride home seemed to take forever. (JC.)

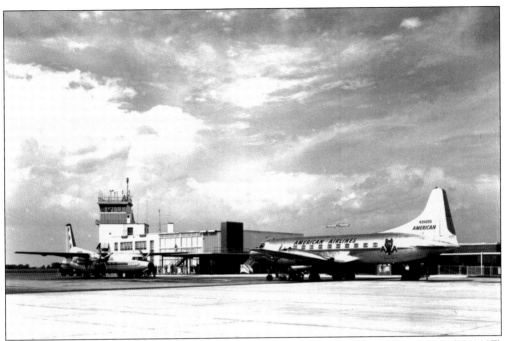

In October 1959, Springfield was poised on the brink of the "jet age." The Ozark F-27 (N4302F) on the left was on a route proving or public relations mission and would not begin scheduled service to SPI for another few months. The dependable American Airlines Convair (N94205) was "yesterday's prom queen" and destined to continue in service for another three years. With the F-27, Ozark Air Lines also introduced the "three swallows" logo. (SAA.)

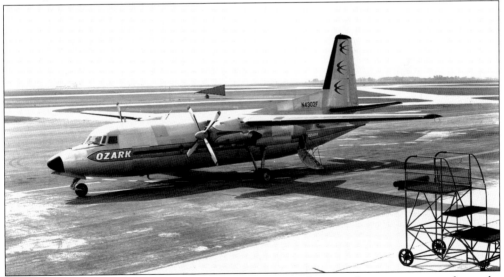

Another view of the Ozark F-27 (N4302F), taken from the new observation ramp, shows the rather drab medium and dark green Ozark Air Lines colors on unpolished bare metal. They did not last long and were replaced by a redesigned "cheat line," (the stripe down the middle of the fuselage) a white top, and a more polished metal finish on the lower fuselage. The 40-seat airliner was Dutch-designed. Many were license-built in the United States by Fairchild of Hagerstown, Maryland. (SAA.)

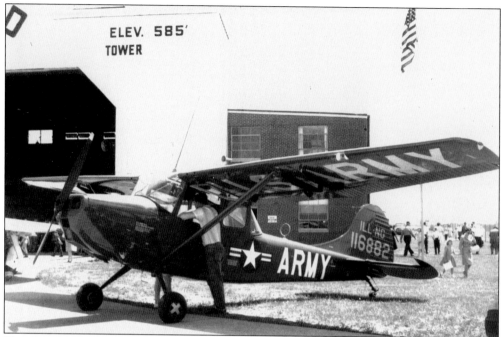

The Cessna O-1 (116882) Bird Dog of the Illinois Army National Guard was displayed at a 170th Fighting Squadron open house on May 10, 1964. During the Vietnam War, deployed with the U.S. Air Force, their crews wrote history close to the treetops, spotting well-hidden enemy and calling in air strikes, aided by forward-air controllers on the ground who traveled with the troops. O-1s were replaced by faster, safer, twin engine Cessna O-2s. (JC.)

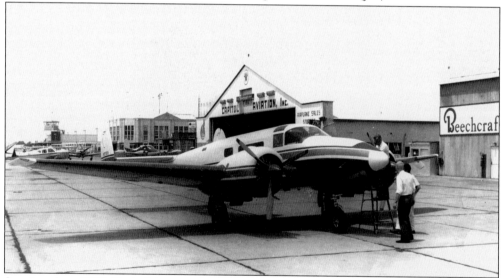

Starting about 1963, Capitol Aviation began Volpar Tri-Gear conversions of Beech 18s featuring new landing gear, interiors, engines, and Airstair doors. Pictured by the nose is Jim Camp, avionics manager at Capitol Aviation. On the ladder is C. S. Hartley, service manager. Today the airplane is based in San Diego. Jim Hartley, son of C. S. and editor of *America's Flyways* magazine, has flown it. The conversions were so popular that Beech produced the last 18s as tri-gear machines. (JH.)

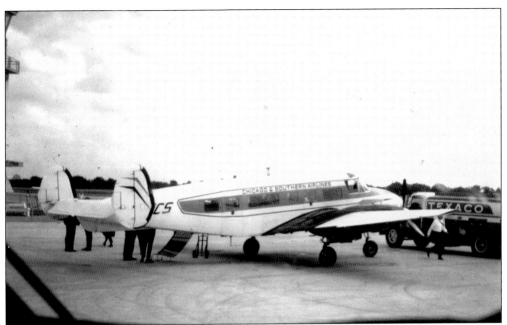

After an absence of 20 years, the name Chicago and Southern Airlines returned to Springfield, but not for long. This Ateco Westwind II turbo-prop Beech 18 conversion (N51CS) was the ultimate upgrade of the venerable Twin Beech, was a well-liked, smooth flyer with the turbines. On October 21, 1971, two months after this picture was taken, 51CS crashed on approach to Greater Peoria Airport, killing all 16 passengers and crew. The airline ceased operations soon after. (JC.)

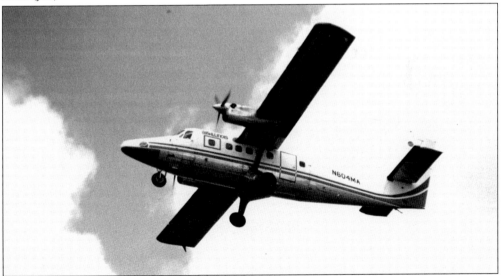

The Canadian de Havilland Twin Otter of Air Illinois (N604MA) is shown climbing out of SPI after a short dash down Runway 22. Intended initially as a replacement for the manufacturer's popular Otter, whose single reciprocating round engine was becoming an aero-anachronism, the Twin Otter proved a practical feeder liner as well. This example, photographed in July 1974 could fly up to 20 passengers and cruise in the 140 miles per hour range, fine for short stage length travel. (JC.)

In September 1967, two adventurers decided to give an about-to-be-married buddy his first airplane ride. On arrival at the Springfield FBO, they were told by the manager, "I should warn you guys. Your pilot is a petite blond who looks like she belongs in high school, but she's an excellent pilot." He was right. Deb Hutson, pictured here before the flight, was as good as promised; she also wrote an aviation column for the SJ-R. (JC.)

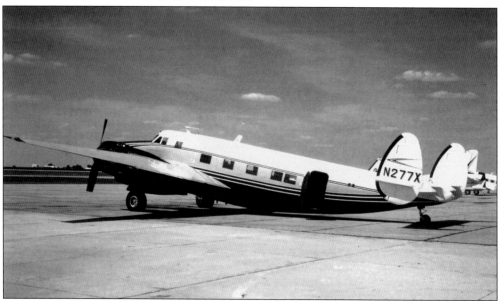

What might be called a Lockheed Learstar on steroids is a Howard 500 (N277X) a highly modified, pressurized cabin, power-boosted tiger in business executives' clothing. Photographed in September 1967, it was instantly recognizable as such with its four-blade propellers and panorama windows. Only a little slower than the new Grumman Gulfstream turboprop, it could fly 200 miles further. Alas, turbine birds were destined to rule the roost. Only 17 were built. (JC.)

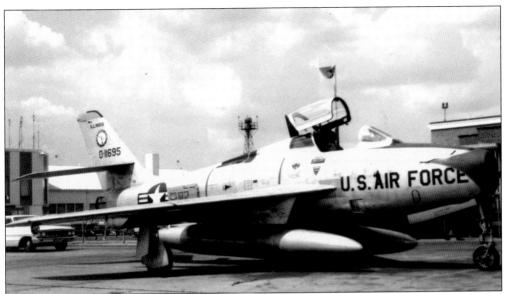

This Republic F-84F (0-11695) was displayed at a Capitol Aviation open house in 1965. The 450-gallon external fuel tanks were necessary to sustain the thirsty Wright J-65 turbojet, and the 170th "Hogs" were seldom seen without them. The aircraft could not be refueled in flight. What looks like painted trim on the nose is a fabric cover for the air intake, essential to keep wayfaring soft drink bottles from being tossed into an inviting target. (JC.)

Probably photographed during summer exercises at Volk Field, Wisconsin, 170th Tactical Fighter Squadron F-84F (11669) crew check a target dart which would later be released in flight for target practice. The Thunderstreak was the last U.S. fighter armed with six .50-caliber machine guns, the same armament carried by the F-51 and F-86. They could also deliver up to 6,000 pounds of ordnance (bombs and rockets) to a target, a respectable load for a jet fighter bomber. (UPI via 183rd FW.)

The first business jet to be based at SPI was the Dassault Falcon, first of a family of French-designed-and-built transports to carry the Falcon name. Later it would be known as the Falcon 20. In March 1969, the elegant jet, owned by Sangamo Electric, was king of the corporate hill at SPI. The interior was custom designed to seat 8 to 16 passengers and cruised in the 500-mile-per-hour range. (JC.)

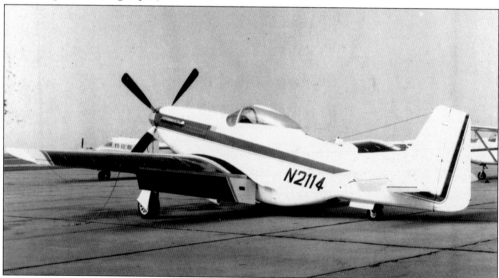

The classic Mustang faded fast from U.S. military service after the Korean War, but some returned to SPI in civilian "clothes." This example (N2114; military serial 44-63634) flew with Sweden's air force and was purchased by Springfield businessman Guglielimo Silni. It had been refurbished and repainted by Capitol Aviation when this picture was taken in 1967. It crash-landed following a cooling system failure on April 21, 1968. Pilot and passenger were injured. (JC.)

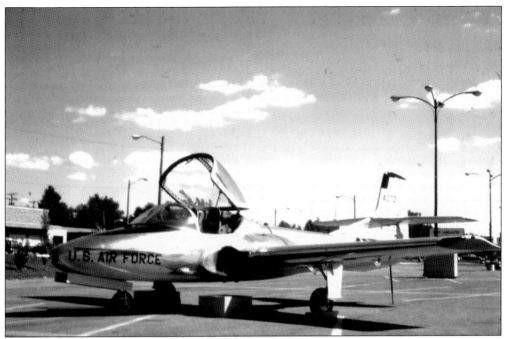

Nothing grabs attention like a Cessna T-37 parked in the middle of the Town and Country Shopping Center on a sunny day in 1972. Dodging the traffic during the rollout must have been a chore. Closer inspection revealed it had been trailered in by a traveling U.S. Air Force recruiter. The tail number (42721) does not jibe with prototype or production serials, so one must conclude this was an exceptionally realistic mockup. (JC.)

The 170th Tactical Fighter Squadron was the last Air National Guard unit to say goodbye to the F-84F and the first to say hello to the fighter version of the McDonnell F-4C Phantom II. Another unit commenced operations with the RF-4C before initial Springfield birds arrived in January 1972. This classic view over the fence (with which the author had become well acquainted) was taken in 1978, the same year his article about the unit appeared in the July *Aircraft Illustrated*. (JC.)

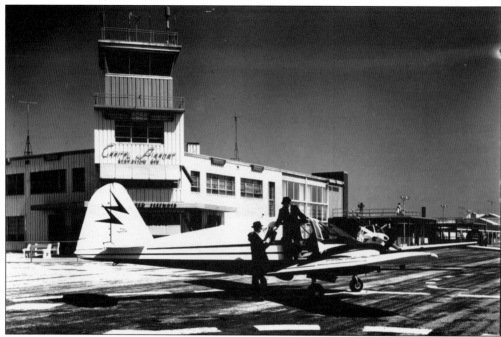

Though it looks really swell, this posed picture of businessmen exiting a Piper Apache (N2189P) in front of the terminal and tower was ultra-contrived. This was airline turf. Offered by Capitol Aviation for charter flights, the Apache was the first post–World War II generation of "light twin." It had Stinson lineage, and the prototype was known as the "Piper-Stinson." Engine out capability was extremely modest. Economical and rugged, many were used as multi-engine trainers. (SAA.)

Following the introduction of the F-4C to the 170th Tactical Fighter Squadron, this Thunderstreak (11822) was selected to remain with the outfit (minus engine) and was displayed on stilts by the road leading to the terminal and general aviation facilities. It was photographed the morning after a snowstorm, followed by a fast thaw in February 1989. The "Hog" is one of just a few jet fighters that never fired its guns in anger. (JC.)

Aeronca was a "runt brother" to the more popular Pipers and Cessnas, who from a distance, all looked alike. But to birdmen like Les Eastep, pictured here in 1963 with his 7AC Champ at Southwest Airport, it was a dream chariot. Purchased in 1961 from the 170th lightplane flying club, he sold it in 1965 to a Beardstown pilot. Eastep ran the Southwest Airport's restaurant and spent many happy hours "poking holes in the sky above Springfield." (LE.)

Flying from the elderly Southwest Airport is epitomized by this restored, or at least repainted, Cessna 140 owned by James Thornton. It was photographed in 1962, shortly before large Xs were painted over the ends of both runways and the western extremity of the airport would yield to "westward ho-ing" residents of the new Westchester Subdivision. For a short time, aircraft would remain hangared there and taxi across active State Route 4 to take off and land. (JT.)

After the big iron vacated Southwest Airport, a healthy assemblage of radio control model airplane enthusiasts moved in. During the mid-1960s, Dr. King and his son (first names not recorded) were among several dozen enthusiasts who flew from spacious grass, the crushed shale runways of old plowed under. Visible in the distance are a hangar and other buildings. The terminal, which had been a surviving fixture at the site, was demolished in early 2008. (JC.)

Six

THE CARBON FIBER AGE, 1976–2008

The writing was on the wall in June 1976, plans for Bert Rutan's revolutionary VariEze canard homebuilt went on sale and added "synthetic fibre fabrication" to the popular aviation lexicon. Aided by Bill Lear's carbon fiber LearFan in the late 1970s and then the all-composite Beech Starship business turboprop, the technology has matured in recent years, simplifying construction and improving fuel efficiency for aircraft great and small.

The nation's bicentennial year witnessed an Airshow America production at Capital Airport, July 30 and 31, featuring the U.S. Air Force Thunderbirds' sleek, economical Northrop T-38s. Earlier the same year, the airport had hosted the first landing by a Boeing 747 when American International Travel Service staged a charter flight from its ample runway.

Airline deregulation brought a parade of new start-up airlines to the city. Most came and went like fireflies in summer. FBOs at Capitol Aviation's original hangar facilities did the same. Today First Class Air directs a thriving general aviation facility from the original SPI hangar, south of a further expanded airport terminal hosting airline service in unhurried environs. In 1980, and soon after the construction of a new control tower, came the construction of the new Charlie Ramp for general aviation aircraft on the southwest quadrant, and in 1986, a new FBO came, McLelland Aviation. Facilities for the FAA, the Illinois Department of Transportation's Division of Aeronautics, and a corporate jet FBO on the northwest quadrant came with the expansion.

To the south of the original airport facilities, Lincoln Land Community College launched a school for aviation trades. Levi Ray and Shoup built a large hangar for its squadron of executive jets near Bunn-O-Matic's aircraft corporate hangar and the Air Combat Museum. Business aviation is alive and well at SPI.

As this book goes to press, the 183rd Fighter Wing, always a fighter unit, prepares to be disestablished late in 2008. The departure of F-16s, dedicated men and women, and economic impact will leave a gaping hole in the heart of the community that has long-cherished them. Military presence at SPI, not yet finalized, seems a certainty.

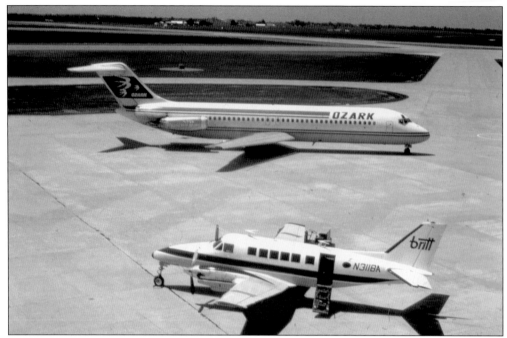

By June 1985, Ozark Airlines, still flying the twin-jet Douglas DC-9s that it had introduced on July 16, 1966, and reeling from the continued helter-skelter brought about by airline deregulation in the mid-1970s exits the apron while the competition, a Britt Airways Beech 99 awaits passengers. Later in the year, Ozark Airlines would discontinue DC-9 service to SPI and for a short while flew Twin Otters to Meigs Field in the heart of downtown Chicago. (JC.)

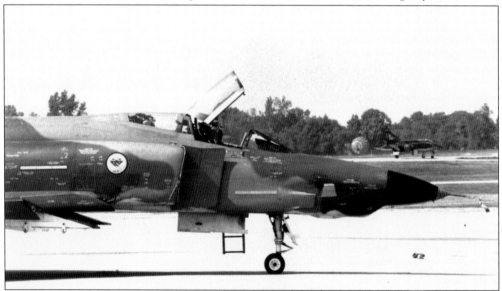

A matter of dispute among aviation historians in the 1980s was the use of RF-4Cs by Springfield's 183rd Tactical Fighter Group (TFG) as the local unit had become known. Photographs taken during the transition years show six RFs, including this one, did carry the squadron and group insignia and were used for proficiency training. Unlike Navy Phantom IIs, U.S. Air Force birds had dual controls in the back seat. (JC.)

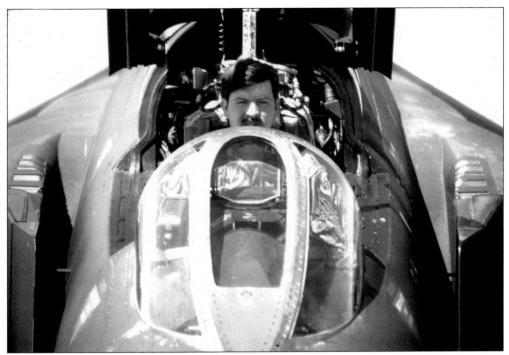

This picture of 183rd TFG pilot Capt. Ken Irland was taken during a photograph session for the 1985 Springfield Air Rendezvous Official Souvenir Program, which the author helped produce. The longtime Phantom pilot had earlier flown RF-4Cs with the Nebraska Air National Guard in Lincoln, and he welcomed the move to pure fighters at SPI. As airspace manager and flight training officer for the 183rd TFG, he averaged three flights per week, a lot of stick time in 1985. (JC.)

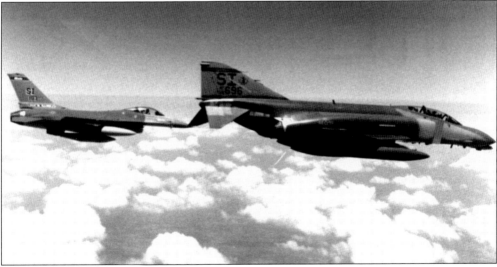

On June 7, 1989, two General Dymamics F-16 Fighting Falcons arrived at SPI to begin residency for the type one year short of two decades long. Photographed en route F-4D (66-196) leads newcomer F-16 (83-083) already resplendent in the unit's new trim colors of orange and blue. The new colors were those of the University of Illinois, and group's new nickname, "The Flyin' Illini," resembled the University of Illinois football team's, "The Fighting Illini." (183rd FW.)

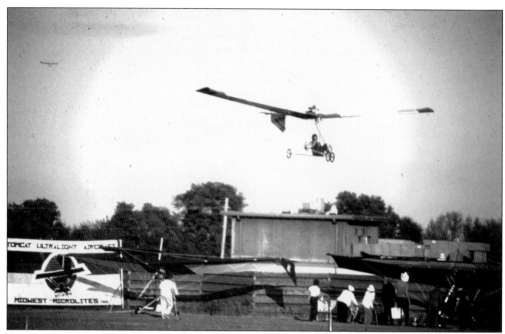

One of Springfield's most unlikely "airports" was Knight's Action Park, just a hoot and holler from the former Commercial-cum-Municipal-cum-Southwest Airport enterprise off State Route 4. During the 1980s, Knight's Action Park hosted several ultralight aircraft fly-ins, where practitioners of that modus recreationus congregated happily and welcomed all comers. The events drew large crowds and helped popularize the fast-evolving sport. (JC.)

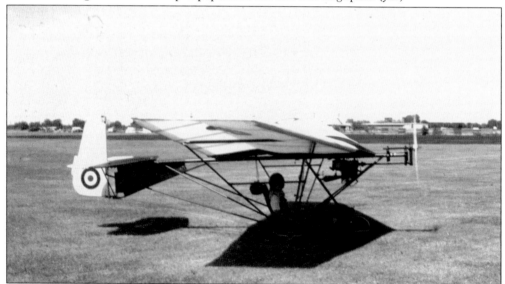

Still flying after all these years, the sturdy Weedhopper ultralight plane photographed in 1983 at Knight's Action Park is being produced by Weedhopper Aircraft in Mississippi. Many early designs, too frail, too complex, or too expensive for the limited capability provided, emulated the dodo bird and disappeared. Requiring no pilot's license, federal certification, transponder, or thrust reversers, ultralights are also fuel and weight limited, but enthusiasts say that they are fun flying, pure and simple. (JC.)

The large block letters on the t-hangar roof identify the home of Penny Stanton's memorable airfield southeast of Springfield, near Riverton. In April 1977, it was home to several lightplane pilots, who liked the gently rolling topography of the only runway and the country charm of the owner, who also ran a Standard Service Station at MacArthur Boulevard at South Grand Avenue in Springfield. Stanton flew an Aeronca Champ. (JC.)

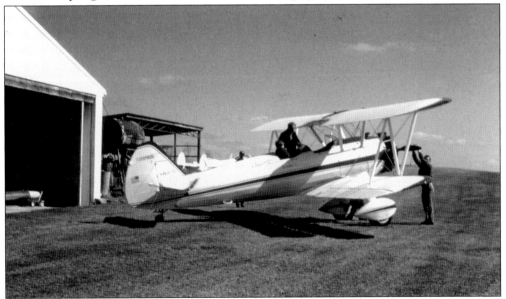

In March 1981, Carl Jiannoni prepared to slip the surly bonds in his Stearman (N46879), *The Impossible Dream* was newly restored by A&P extraordinaire Ron Anderson, who operated a repair and restoration shop at Stanton's. It bore the official colors of many Anderson restorations: medium blue and gold on white, colors also flown on Stanton's Aeronca Champ. Jiannoni is a citizen of Rochester, Illinois. (JC.)

A Cessna Cardinal looks out on Springfield Southwest Air Park, launched by Ron Anderson in 1986 on 20 acres. Located a few miles west as the crow flies from the remains of Southwest Airport, the north/south runway (2,700 feet plus overruns) is adequate for Anderson's clientele. Display cases in the office offer pilot gear for sale, and a large hangar adjacent to the restoration facility shelters birds of a feather that like to fly from uncontrolled grass. (JC.)

Anderson has earned national acclaim for his Stearman restorations. On a sunny day, the glare from the brass trophies lining the office walls can nearly blind a visitor. He takes on other projects including the Cessna 170 pictured here in March 2008. The site is an airpark, not an airport or a restricted landing area. Pilots planning to visit by air must call ahead (a New Berlin exchange) before dropping in. (JC.)

In the late 1970s, Capital Airport expanded big time with t-hangars on the new southwest Charlie Ramp and a control tower on the far west. On the north appeared new FAA offices, a security facility next to the new Garrett AiResearch FBO, and the Illinois Department of Transportation's (IDOT) Division of Aeronautics headquarters, pictured here. This view from a visiting FAA Boeing 727 shows the IDOT aircraft lined up for a June 1980 open house. (JC.)

Though it is known that Gov. Henry Horner flew to affairs of state in the 1930s, records of IDOT aircraft in the early years appear lost. The almost exclusive preference for sturdy Beech aircraft is evident from their operation of a series of King Airs, a Baron, and this Duke (N98ILL). A pressurized cabin six-seater and a delight to fly, the design was an expensive maintenance hog; 584 were built. (JC.)

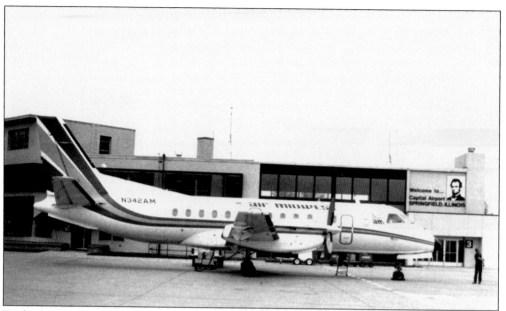

With the growth in commuter-liner traffic came larger transports to serve it, including this Swedish-built Saab 340 (N342AM), photographed at the now–control towerless terminal in November 1985. Air Midwest operated as Ozark Midwest during its service to SPI, though not all aircraft displayed the name. Code sharing allowed bookings through Ozark Midwest on an airplane operated by the Kansas-based airline. What one anticipated as a flight to St. Louis on a DC-9 would be flown on a Saab. (JC.)

George Celani is a name that will forever live in infamy in the hearts of many Springfieldians. He convinced city officials and businesspeople to help finance the launch of Kayport Package Express, an overnight delivery service. It was a scam. During the opening festivities in May 1, 1983, Celani, standing right with his arm around Capital Airport manager Charles Johnson addressed a crowd while Mayor Michael Houston, far right, looked on. (JC.)

Following the speeches, Ed Shaw ascended in his hot air balloon, inaugurating his "Wake Up America, Keep the Faith and Love of Your Country" campaign sponsored by Kayport Package Express. Earlier in the day, a Mitsubishi Diamond I and other light jets appeared in front of the Kayport Package Express hangar prior to the first evening of operations. A Kayport Package Express label decorated the aircraft. (JC.)

The Diamond I would later be marketed stateside by Beech who renamed it the BeechJet. The design competed with Cessna's light jet Citation. It was not an ideal cargo hauler. Federal Express had begun in 1973 with a fleet of larger Falcon 20s. A week after opening ceremonies, the almost-100 Kayport Package Express employees were given layoff notices. The rest of the story was written in the courts. Celani went to jail for his crime, but the bitter aftertaste lingers at SPI. (JC.)

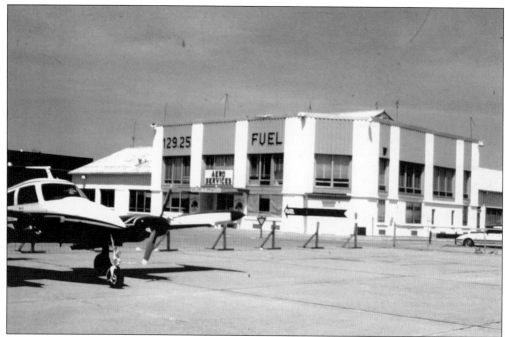

By August 1981, the original airport terminal had hosted several businesses, the last being Aero Services that offered fuel. Not even the attached aluminum white and light blue facade could hide the original windows and general "yesterday" feel of the building erected with hope and pride in 1947. (JC.)

By October 1981, the facility showed unmistakable signs of permanent "terminal distress." In the background, the greatly expanded structure built onto the original control tower in the mid-1950s remained. The newly created detritus was swiftly deposited elsewhere. On a still day, standing in this part of the asphalt lot of parked rental cars and visitors to FBO First Class Air, one can almost inhale the aroma of perspiring DC-3 passengers, coffee, burgers, and sun-drenched vinyl. (JC.)

In May 1987, the author, driving home from church, encountered this Erickson Air Crane Sikorsky S-64 parked downtown next to the Lincoln Towers apartments. On return with camera in hand, efforts to lift a replacement air conditioning compressor to the rooftop of that facility were underway. The view of downtown's Central Baptist Church and Forum 30 hotel in the distance would not be possible today. After the airlift, another building blossomed in the parking lot. (JC.)

This seal commemorating the 50th anniversary of Capital Airport was evident throughout the terminal during the anniversary year, particularly during the terminal's open house commemoration in 1997. Educational exhibits, including a large arrangement of model aircraft from the AeroKnow Collection, were displayed throughout the thoroughly modern facility on that special day. (AK.)

Decades after the 170th Tactical Fighter Squadron had ceased operations from the southeast end of the general aviation ramp, this trace of the unit was encountered in the grass. It is pierced steel planking, called PSP for short, and during World War II called Marston Matt. Sections of it, 15 inches long and 10 feet wide, were linked together as seen here to provide a relatively clean, rut-less hard surface for aircraft operations. After the 170th Tactical Fighter Squadron moved, rows of lightplanes were parked in the same area by pilots who did not want to rent hangar or t-hangar space. (JC.)

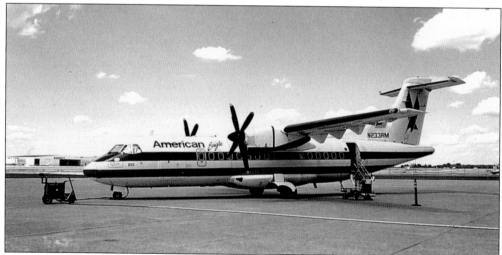

With the exception of the jet Fokker 100s, which American Eagle operated from SPI about a year, the Italian-French-built ATR-42 (N233RM) was probably the slickest airliner to grace the apron. This example was photographed in July 2000. Well into its service career, the 48-seat turboprop was found to be unstable in icing conditions when water droplets froze on the wings. The company moved ATR operations to routes in Southern states where icing was less frequent. (JC.)

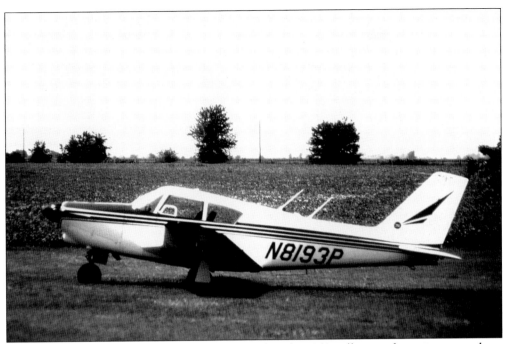

The Bill Copp family plumbing business prospered in the 1960s, allowing the senior to purchase and fly this elegant Piper Comanche 250 (N8193P), photographed at a grass strip west of the city in August 1985. The Copp children became pilots as well. They were among the most active participants in Slip 'N' Skid flying club group flights throughout the Midwest. Today the Comanche is owned by Bill Copp Jr., an air traffic controller in Denver. (JC.)

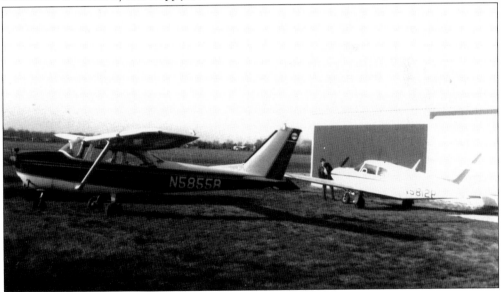

At a small strip between Lake Springfield and Pawnee in the 1980s, Ralph Luchsinger preflights his Comanche 180 as his waiting passenger snaps a picture. Owner Dave Holmes created the 4,000-foot (plus displaced threshold) east/west runway in 1981 so he could hangar his Cessna 172 close to home. Today he hosts and hangars ultralight aircraft and an emergency helicopter FBO and welcomes radio control model flyers. Service and fuel are unavailable. (JC.)

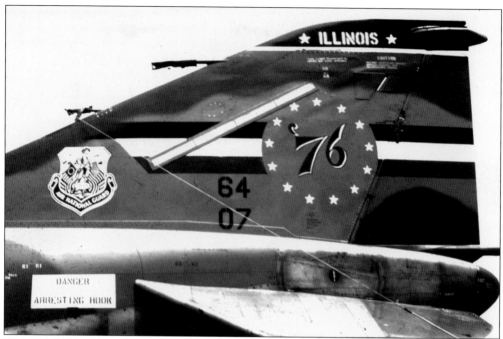

This 183rd TFG Phantom (64-0776) was the only unit aircraft to display bicentennial markings in 1976. It also carried a MiG kill marking on the left intake ramp. The Air National Guard emblem on the lower front of the fin was also a bicentennial marking. The F-4C and D flown by the unit, like all Navy Phantoms, carried no built-in gun armament because strategists anticipated missiles alone would suffice. They were mistaken. (JC.)

For several years, until late 1999, Capital Aircraft was more than an FBO at Springfield's original hangars. The firm was a jetliner and parts broker as well. During those years, it was common to see DC-9s on the ramp, including Ozark's first in TWA colors. This Mooney M20J (N201HT), in transit from Michigan in July 2000, is parked on the same spot where the Mooney Mite, pictured earlier, revved his engine before departing SPI in 1950. (JC.)

The intact B-25H (N5548N, ex 43-4106) was acquired by Springfield's Heritage In Flight Museum in partnership with the Weary Warriors of Northern Illinois in 1981. It was flown to SPI from Plainfield. The partnership proved less than perfect, and the Mitchell was returned to the Weary Warriors of Northern Illinois, where restoration was completed. Today it flies as *Barbie III* with a disabled 75-milimeter cannon mounted in the nose, based in Mesa, Arizona. (JC.)

This restored Piper J-3 *Cub* (NC30595) broke a perfectly good propeller following Heritage In Flight's first fly-in, in July 1982. Dave Slaybaugh of Decatur saw the author, stopped, stood on the brakes, and gently raised the tail. He had done this little trick many times before. On this day a gust of wind caught him and forced the tail too high and the plane tipped over onto its nose, resulting in the scene here. (JC.)

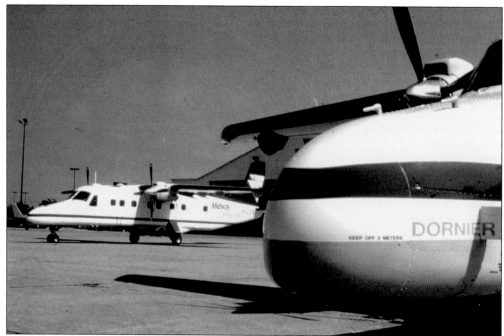

Midway Express burst into the Springfield scene with 19-seat Dornier 228 turboprops. The high-tech wing looked smaller than it should have been but delivered good performance on flights in and out of Chicago's long-neglected Midway Airport. At the start, the airline almost single-handedly popularized commuter service to the once-thriving airport. The good times were short, and the Dorniers were parked on the SPI general aviation ramp until their sale. (JC)

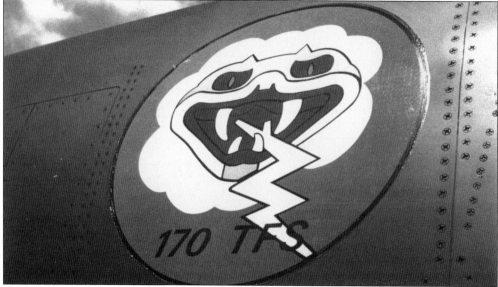

This is the insignia of the 170th Tactical Fighter Squadron of the renamed 183rd Fighter Wing, Illinois Air National Guard. It consists of a grey rattlesnake head with yellow lips, fangs, and lightning, on a white cloud with a medium blue base. The lettering and outlines are black. A fighter unit from its start at Capital Airport through its dissolution slated for late 2008, the men and women are and were shining assets to Springfield and to the cause of freedom. (JC.)

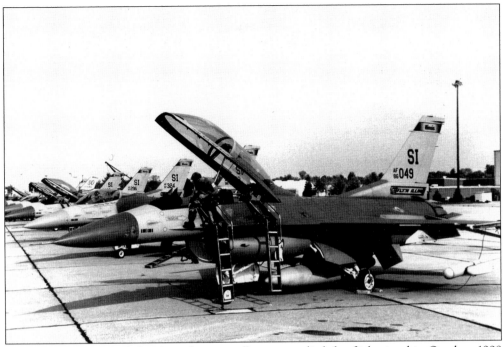

Two two-seat F-16Ds (86-049 in foreground) were readied for flight in this October 1998 picture. Just a few tandem Bs, and later Ds, flew with the 183rd Fighter Wing. Used primarily for proficiency training they were also employed to give "incentive ride" rewards to unit members whose superior performance earned them the rides. (183rd FW.)

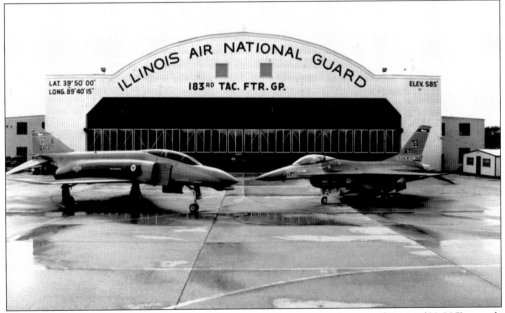

Close examination of F-4D (66-468) posed on the left with a newly arrived F-16A (82-995) reveals it is a "phormer" Phantom: stripped of internal equipment, canopies replaced with opaque covers and slated for display on a pedestal outside the base entrance. Since the early 1990s, it has remained a gate guard in the company of a Republic F-84F and North American F-86E. (183rd FW.)

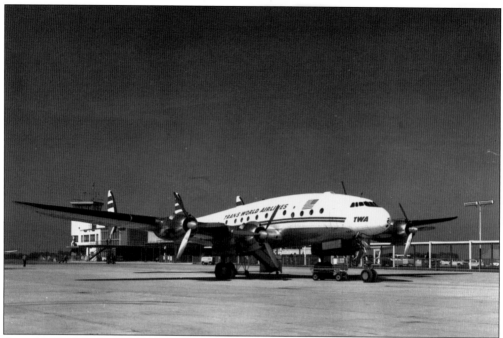

Arguably the best looking airliner built, Lockheed's Constellation in TWA livery visited SPI for a charter flight about 1958. This early 749 version of the *Connie* was the aesthetic zenith of the design before the later 1049G appeared with a bulbous radar nose and wing-tip-mounted fuel tanks. Though TWA would never fly scheduled service from SPI, their TW Express commuterliner subsidiary did, flying Fairchild Metro IIs and IIIs before going belly up in 1995. (SAA.)

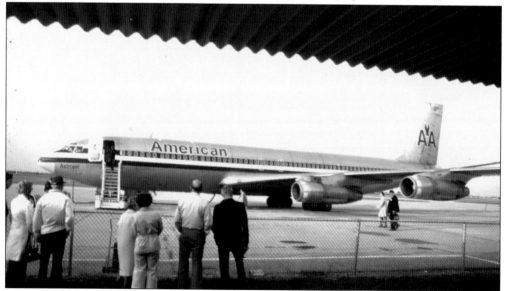

Charter airlines have long appreciated SPI's long runways, fine navigation aids, and tower professionals. As a capital city, everyone can find it on a map. Over the years, visiting types have included almost every airliner built including a Concorde, Boeing 747, and this Boeing 707 (N8414). It was photographed during October 1974 from the covered walkway between a terminal and a parking area. American called their Boeings "Astrojets." (JC.)

Based in Terre Haute, Indiana, Britt Airways, founded in 1976 by Bill Britt, served SPI long and well until its 1990 demise. Everything in its inventory found its way through Springfield, starting with Beech 99s, Twin Otters, F-27s, and ultimately the British Aerospace Corporation BAC-111 pictured here. Britt Airway's primary nemesis, Air Illinois, matched them move-for-move but operated new Hawker-Siddeley 748s to Britt Airways's Fokker F-27s. Both briefly flew BAC 111s. (AK.)

Air Combat Museum is a jewel of a collection, located off the first airport entrance in the hangar provided by George Alarm Company. It contains company business aircraft plus an immaculately restored P-51D, F4U-5, Taylorcraft L-2M, Soko Galeb, Beech T-34, and other projects in process. The museum's AT-11 is hangared elsewhere but appears often at Midwest air shows. Visitors are welcome; guided tours are by appointment. (JC.)

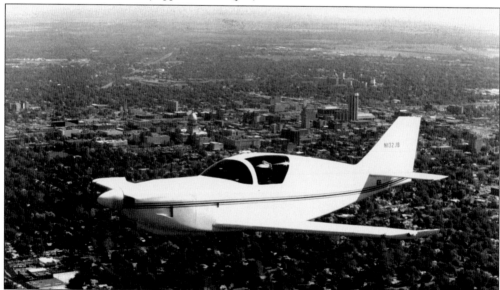

The Glasair I (N132JB) was built by Richard Davis of Chatham and owned by John Barber of Springfield. It was photographed over the city's near south, looking northeast. The side-by-side two-seater cruised at 225 miles per hour. Health issues forced both men out of the cockpit, and the airplane was dismantled prior to sale. Somewhere two Glasairs fly today: one with wings and propeller from 132 Juliette Bravo and the other with the rest of her. (JA.)

Seven

SPRINGFIELD AIR RENDEZVOUS

In 1982, the Heritage In Flight Museum of Springfield held its first open house and semi-official air show. No aerobatics were permitted, but there were airplanes a plenty and a good crowd. The author's picture of Bill Leff flying his North American AT-6 Texan at that event would grace the cover of the first Springfield Air Rendezvous (SAR) program published a year later. Created by a group that included Fred Puglia, creator of LincolnFest, a downtown summer entertainment festival, and chaired by Cynthia Posegate, the first year's show took place on the original southeast quadrant. It would move to the northwest for the following 23 years so airlines and general aviation operations could continue unaffected by the crowds and activities on the other side of Runway 22.

The roster of nationally known performers who rendezvoused over Springfield includes Bob Hoover, Patty Wagstaff, Leo Loudenslager, Duane Cole (who had performed over Southwest Airport in 1955), Jimmy Franklin, U.S. Army Golden Knights, the Blue Angels, Thunderbirds, Canadian Snowbirds, and Les Shockley in his jet-powered Shockwave jet truck.

Early shows witnessed a parade of board and office managers until consensus dictated consistency. As a result, a family of familiar faces refined the process to a near art form, always with inevitable speed bumps but also with equanimity and focus toward successively better events.

Central Illinois became spoiled. Without a jet demonstration team, many aviation fans stayed home or watched from the outside. Silas M. Brooks would have sympathized, having suffered the same fate in 1858.

By any measure, 24 years was an outstanding run for an organization of thousands of dedicated volunteers that channeled thousands of dollars to area charities and won its share of national awards. Low turnout closed the door. Pending loss of 183rd Fighter Wing flight operations and the elimination of its generous support of military presence at SAR pretty much locked it.

From 1983 through 2006, SAR wrote a unique "chapter" into the annals of Springfield aviation history, a story that will remain bright and shining in the memories of those who were a part of it.

The cover photograph for the first SAR Official Souvenir Program had been taken the summer before during Heritage In Flight Museum's first open house. It showed Bill Leff making a low pass down Runway 24 in his shiny North American T-6G Texan. The distant Illinois State Capitol appeared far closer than actual, because the telephoto lens used shortened perspective. Headliners included Chuck Carothers, Ed Johnson's BD-5J, and a restored 1930s vintage Stinson Trimotor. (JC.)

What Sangamo Electric was to Springfield in 1958, Levi Ray and Shoup, information technology company, is in 2008. Among its squadron of flying chariots is this Cessna Citation X (10 to non-Romans), the fastest business jet in aviation history. With seating for 8 to 12, a range of almost 3,250 miles, and a top speed of 703 miles per hour, the X ranks at the head of its class. It was displayed at SAR in 2004. (JC.)

Charlie Wells was a major force in Illinois aviation, first as manager of the Salem, Illinois, airport where this author first met him in 1968 and then with the IDOT Division of Aeronautics, where he flew almost daily as a facilities inspector. He was popular at Midwestern air shows, as much for his convivial personality as his consummate skill in the cockpit of his Pitts Special. (SAR.)

Until his death on August 22, 1993, performing at Bloomington, Illinois, Wells urged Piper and Cessna pilots to learn basic aerobatic flight maneuvers in aircraft stressed for such training. He believed that by better understanding how an airplane behaves in unusual positions, pilots would be better able to fly safely out of them. There are untold numbers of pilots alive today who knew Wells, flew with him, and will say that he was absolutely right. (JC.)

The postal cachet created for the first SAR explained that the event was part of a nationwide observance of the 200th anniversary of human flight. On November 2, 1783, just 164 years to the day before the dedication of Capital Airport, a French scientist and French aristocrat ascended skyward in a Montgolfier brothers hot air balloon over Paris and safely descended to earth 20 minutes later. The "fly" was cast. (JC.)

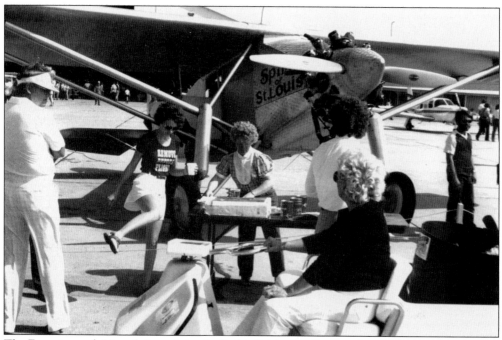

The Experimental Aircraft Association built this *Spirit of St. Louis* replica and flew it during SAR 1983. Unlike Charles Lindbergh's original, the replica was not intended to fly across the Atlantic, so the large fuel tank that had been placed in front of him for the record flight was not built into the modern incarnation. Metal panels, placed over the front during static displays to better simulate the original appearance, were removed and stored for flying demonstrations. (SAR.)

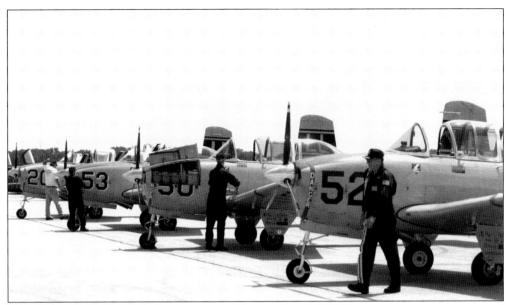

At first glance, this picture of a lineup of 1950s-era Beech T-34 Navy trainers seems misplaced here. Closer examination reveals them to be restored aircraft flown by Lima Lima Flight Demonstration Team as they preflight their aircraft July 15, 1995. Though most appearances feature six aircraft, the team includes several more pilots and aircraft, all painted similarly. This allows them to fly when a regular roster member is committed elsewhere. (JC.)

On October 12, 2002, the author flew with Lima Lima Flight Demonstration Team on an early morning publicity flight. The pilots gladly accommodated wishes for a flight that would position the team between the camera and the Illinois State Capitol, and following that pass, the team proceeded due west of the city for some impromptu tail chasing and moderate high jinks. Stress limitations on the Mentors's wing spars prevent flat-out aerobatics, but the flight was a heaping helping of unforgettable fun. (JC.)

During the latter years of the show, a Boeing CH-47 Chinook, based in Peoria and positioned at nearby Camp Lincoln, "presented colors" as seen here in 2006, with a weighted American flag suspended beneath. The U.S. Army aviation presence was always all-out. It included displays of non-flying equipment and simulated encampments, and usually a Bell OH-58, Sikorsky UH-60, often a Boeing AH-64 Apache, and a second Chinook were on hand in the heart of the air show grounds. (JC.)

The city's *Illinois Times* news weekly paid special attention to SAR in 1985 when photographer Linda Smogor went for a scenic ride perched on the top wing of Ron Shelly's magnificent Stearman. Posing for this picture, the intrepid photojournalist was at the top of her profession. Months after the event, she moved to Alaska, attracted, perhaps, by the paucity of air shows in that region. (JC.)

On August 23, 1991, the author flew with the Red Baron Stearman Squadron on a media day "thank you" flight in which many contributors were acknowledged. The pilot's instructions for parachute egress in an emergency included, "Don't forget to unplug your headphones or you'll stay with the airplane after you attempt to leave it." The flight was as exciting as the VIP with the most sensitive stomach wanted it to be, but the formation flying was extremely close; almost heart-stopping from inside a front cockpit. The year 1991 was one of the last the Red Baron Stearman Squadron flew with the pants (teardrop-shaped fairings over the wheels) attached. In their final years, the pants were removed because of weight issues. To some fans, flying without them was like going to the prom in socks. The Red Baron Stearman Squadron disbanded in 2007, but they will never be forgotten by those privileged to see them perform. (JC.)

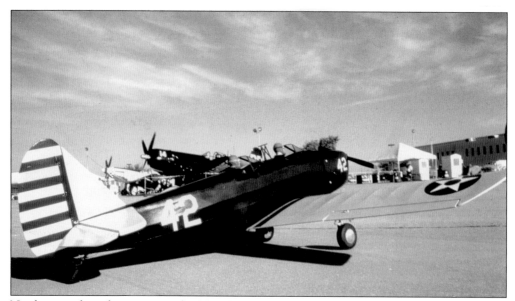

Newly arrived on the tarmac at the 2000 SAR is Dave Taylor's pristine Fairchld PT-19 Cornell. Readers with an eye for detail may have noticed by now that the Fairchild is a radio control model, part of a large static display of radio control planes displayed most years and actually flown one year. In the background are the real things: Mike George's restored P-51D Mustang and F4U-5 Corsair from the Air Combat Museum. (JC.)

Springfield is also headquarters for a group of uniform collectors and reenactors, among them this unidentified "ace." George's P-51 behind him (n5445V, ex 44-73287), nicknamed *Worry Bird*, carries the markings of a Mustang flown by 339th Fighter Group's Lt. Robert J. Frisch who destroyed six enemy aircraft during ground strafing missions in Europe during World War II. The restoration was named Reserve Grand Champion at a national Experimental Aircraft Association Oshkosh "Airventure." (JC.)

The U.S. Air Force Heritage Flight program, which brings military aircraft into formation fly-bys with highly trained civilian warbird pilots, has been one of the more memorable moments of any air show, especially SAR. In 2002, watching Ed Shipley in his F-86 lead an F-16 down "air show central," brought misty memories to any who served with Springfield's 170th TFS from 1953 to 1955, and a feeling of appreciation and pride to those who did not. (JC.)

Springfield's longest running air show was blessed by two on-the-ground displays of Lockheed's F-117A and a flyby of Northop's exotic B-2 Spirit in 1999. Aviation enthusiasts were particularly dazzled by the regular display of the only known "Stealth Lightplane," built and owned by local pilot James Thornton, pictured here in 2004. Note the barrier erected to prevent visitors from walking into a wing. Details of this advanced design remained secret at press time. (JT.)

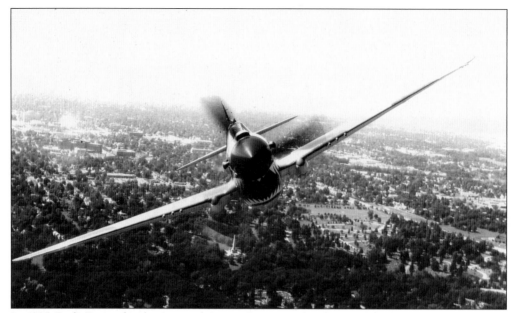

In 1985, Rudy Frasca flew his restored Curtiss P-40E Warhawk to SAR. During the early years of the show, Warbird owners flew early morning sorties over the city to remind those below about the air show. In 1985, this author rode in the tail turret of *Fairfax Ghost*, a restored B-25 from Kansas City, Kansas. Frasca flew along for a photograph shoot. This picture was taken as Frasca banked the Warhawk and flew over Lincoln Tomb. (JC.)

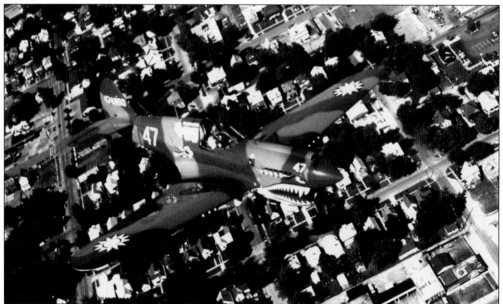

With its camouflage colors, it is hard to see Frasca's airplane against this view of Springfield's near south side. Warhawks, flown by the American Volunteer Group (better known as the Flying Tigers) and led by Gen. Claire Chennault, were China's primary defense against invading Japanese in 1942. In July of that year, they became part of the USAAF 23rd Fighter Group. Frasca's aircraft, based at Frasca Field in Urbana, Illinois, carries markings of American Volunteer Group member John Petach. (JC.)

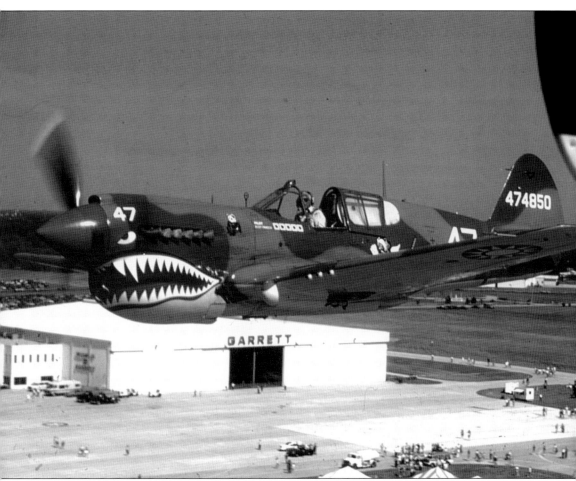

With the tail of the B-25 visible on the right, a Warhawk and Mitchell sashay down Runway 22. Garrett's thriving Springfield facility expanded to triple the size evident in 1985 and is now owned by Landmark Aviation. The company serves a worldwide clientele of business jet owners. Garrett and its successors generously supported SAR through the years. With its Allison engine, P-40s flown by the RAF in North Africa helped defeat Gen. Erwin Rommel of Germany. USAAF Hawks, flown in Alaska, led by General Chennault's son, and known as the Aleutian Tigers, kept the Japanese at bay until the drive to their homeland began. Soviets used them successfully in their "low altitude war" against the Germany on the Eastern Front. This P-40 was built in 1942 and was assigned Royal Air Force serial AK905. Today Rudy's son David flies the airplane regularly. (JC.)

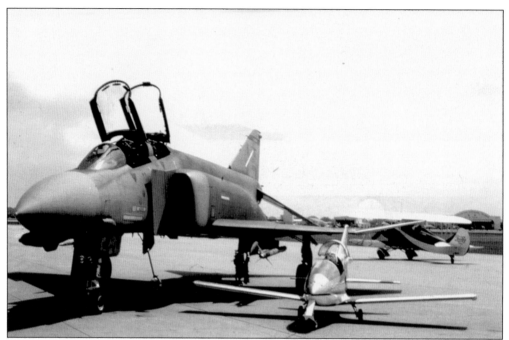

At SAR 1987, the Coors Light Silver Bullet BD-5J (N21AP) was parked beside 183rd FG F-4D (67659) as Pepsi skywriter Suzanne Asbury-Oliver taxied in following some "name dropping in the sky." Flown by Bob Bishop, the BD-5J, with its wingspan of just 17 feet, was the smallest aircraft to fly from Capital Airport. With its two GE J-79 turbojets producing 17,900 pounds of thrust each, the F-4D was probably the noisiest. (JC.)

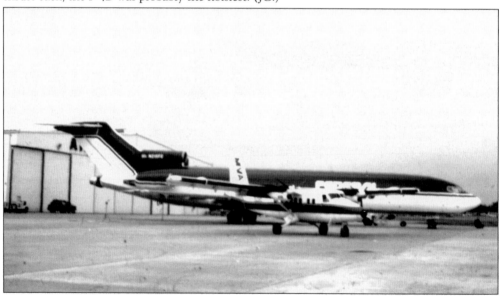

Since an airplane sitting on the ground going nowhere does not make money for its airline, it is understandable why so few appeared at Springfield Air Rendezvous. Two glad exceptions were the Mississippi Valley Airlines Twin Otter and FedEx Boeing 727 (N215FE), the last 727 Boeing built. Mississippi Valley Airlines served SPI with Shorts 330s and the rare single-tail 360 before closing all doors and selling assets. (JC.)

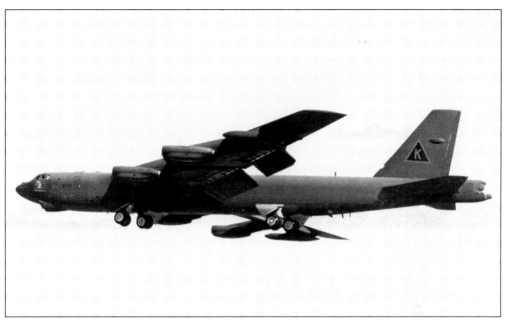

Perhaps because it was a bear to maneuver on taxiways or perhaps because of security concerns, SAR never hosted a ground-displayed Boeing B-52, the backbone of the U.S. strategic bomber force since the mid-1950s. This example did drop in for a few impressive low-altitude passes during SAR and landed but was parked at the 183rd Fighter Wing apron across the airport. (JC.)

Often the best time for pictures is after the performances. On September 12, 2004, from left to right, wing walker Kyle Franklin, *Bulldog* pilot Jim LeRoy, and legendary Jet Waco pilot Jimmy Franklin posed with their aircraft behind them. Ten months later, Jimmy fatally crashed at an air show; LeRoy died performing in July 2007, both at the top of their profession. Kyle Franklin now flies a tamer Waco (no jet) and is a rising star in his own right. (JC.)

Though no one realized it at the time, the cover of the final SAR souvenir program would be chosen in a citywide contest won by Springfield artist George Hinds. The event included the first SAR performance by the F-15E Strike Eagle Demo Team, U.S. Jet Team, Mark Hagar Dangerous Moments Stunt Team, the last performance by veteran crowd pleasers Lima Lima Flight Demonstration Team, Dan Buchanan's aerobatic hang glider act "Flying Colors," and others. (JC.)

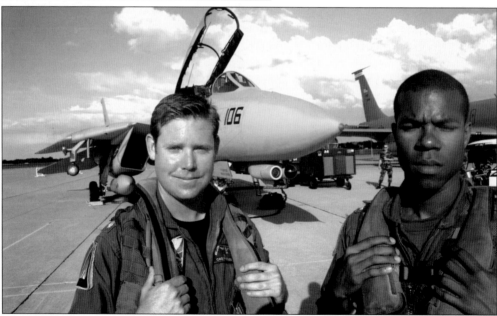

The last SAR plane to depart on the last day was Grumman F-14D (164343). Within a month, F-14s would be retired from U.S. Navy operations. To many SAR volunteers who lingered after the gates closed, its departure was particularly poignant. The author talked with the courteous pilot (left) and weapons systems officer before they climbed aboard. Their return home was delayed by bad weather, and frequent calls were made via cell phone by the pilot to weather people to check the storm's progress. (JC.)

126

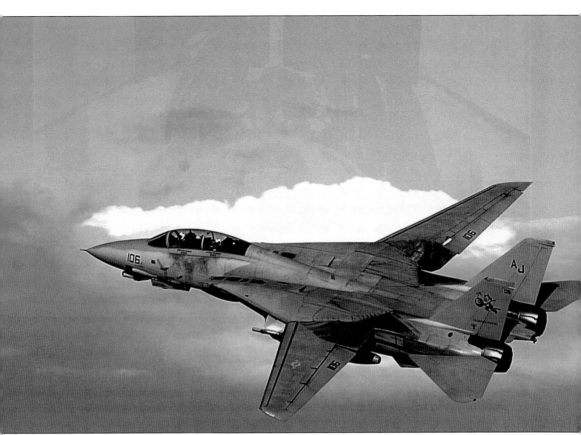

As the billowing clouds in the east began to turn salmon and pink, the F-14 launched northeast down Runway 4. The airplane was one of the last of its type on the roster of the last squadron to fly them: U.S. Navy fighter squadron VF-31 "Tomcatters," which had flown the type since 1981. The crew knew their Tomcat would be the last seen in Lincolnland skies, and they were exceedingly generous in giving the lingering assemblage at the air show headquarters trailer something to remember. They flew three unforgettable passes just a few hundred feet above the runway before banking westward and disappearing into the setting sun. Citizens looking up at the airplane climbing to cruise altitude over southwest Springfield did not know they were seeing probably the most powerful fighter aircraft destined to fly through their air. Now they do. Craig Isbell and Corky Meyer would have been proud. That is what folks call Springfield aviation history. (JC.)

ACROSS AMERICA, PEOPLE ARE DISCOVERING
SOMETHING WONDERFUL. *THEIR HERITAGE.*

Arcadia Publishing is the leading local history publisher in the United States. With more than 3,000 titles in print and hundreds of new titles released every year, Arcadia has extensive specialized experience chronicling the history of communities and celebrating America's hidden stories, bringing to life the people, places, and events from the past. To discover the history of other communities across the nation, please visit:

www.arcadiapublishing.com

Customized search tools allow you to find regional history books about the town where you grew up, the cities where your friends and family live, the town where your parents met, or even that retirement spot you've been dreaming about.